San Francisco Observed

A Photographic Portfolio from 1850 to the Present

by Ruth Silverman with a Foreword by Herb Caen

Chronicle Books San Francisco

For Jeanne Wahl Halleck

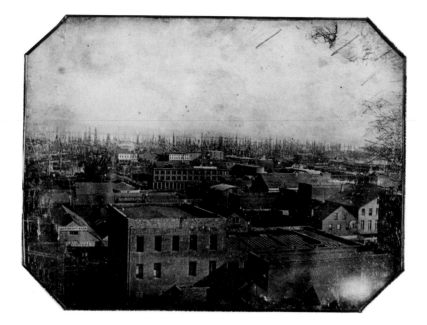

Anonymous
San Francisco, c. 1852 (said to be earliest photograph of San Francisco)
Daguerreotype

Printed in Japan by Toppan Printing Co., Inc., Tokyo, Japan

Library of Congress Cataloging in Publication Data

Silverman, Ruth.
 San Francisco observed.

 1. San Francisco (Calif.) — Description — Views.
2. San Francisco (Calif.) — History — Pictorial works.
I. Title
F869.S343S46 1986 979.4'61 86–14708
ISBN 0-87701-388-8 (pbk.)

Photo credits appear on page 119.

Book and cover design by Fearn Cutler
Composition by TBH/Typecast, Inc.

10 9 8 7 6 5 4 3 2 1

Chronicle Books
One Hallidie Plaza
San Francisco, CA 94102

Foreword by Herb Caen

San Francisco is among the most elusive of great cities. The fact that it is a tiny principality (about 49 square miles) only adds to the alluring mystery. Its borders are finite, unyielding, and its history short, as the time of cities is reckoned, and yet centuries of drama, comedy, and tragedy have been enacted on its peopled hills and in its shadowed valleys.

The restless city changes as fast as the light through scudding banks of fog. Dynasties and monuments rise and fall. The center of pomp and glory changes from South Park to Rincon Hill to Nob Hill and out into the hushed faubourgs of Pacific and Presidio Heights. Entire populations move around in great migrations that cover a few short miles and long years of history. The Irish disappear from the Mission, the Hispanics arrive. The Chinese at last spill out of their pagoda'd ghetto, seeping into Italian North Beach and flooding the once-homogeneous Richmond. The old families with their inherited wealth and power, retreat to the more orderly suburbs, opting out of the fray but still exerting their discrete pressures.

The face of the city changes overnight. Buildings you could swear weren't there yesterday suddenly rise to scrape the sky, which is what skyscrapers do. Landmarks that seemed like old friends, even members of the family, fall into rubble or disappear into gaping holes. Only when it is almost too late are the remaining jewels recognized for their true value—the great gingerbread Victorians, the Bay-viewed, bow-windowed old beauties, the early office buildings with their elaborate ornamentation, the last concrete ties with San Francisco's short but tempestuous past.

The Sanfranciscophile is forever tortured and fascinated by the city that was. Who were these people, his predecessors, who built a world city almost overnight, who amassed great fortunes in gold and silver, whose character and confidence allowed them to face catastrophes (fires, earthquakes) with such seeming equanimity? In search of answers, he reads and rereads the adventures of Billy Ralston, who built the original Palace Hotel; Mr. Sutro and his Comstock Lode tunnel; "Bonanza Jim" Flood and James Duval Phelan, with their visions of the city beautiful. He walks the streets of Chinatown, imagining the gorgeous mandarins and slit-eyed assassins who prowled the alleys that still remain. He thinks of A. P. Giannini and the first wave of Italian immigrants whose influence is still felt in high places, and he muses about the infamous cribs, the Barbary Coast deadfalls, the villainous anti-Chinese campaigns of Denis Kearney, the naughtiness and excesses of the Mauve Decades, all candlelight, satin, and muffled giggles.

Most of all, he pours over the incredible photographs that mirror a time that now seems beyond reach, as though it happened centuries ago. Everything is so different—so, if you will, "foreign": the grim-visaged men with their heavy moustaches, the women in their unbelievable hats, the European downtown buildings, the block after block of imposing houses. In the end, it is the photographers who tell us most vividly of who we are and where we come from—from the days before the great bridges to the frantic world of gridlock and The New City, whose face is at once imposing, frightening, and even more foreign than the vanished face that haunts our dreams.

This splendid book encapsulates the many lives of the restless city. Here part of the truth is pinned down between covers. The restless spirit may never be captured, any more than lightning in a bottle, but the search will always go on. This book is a major signpost along the way.

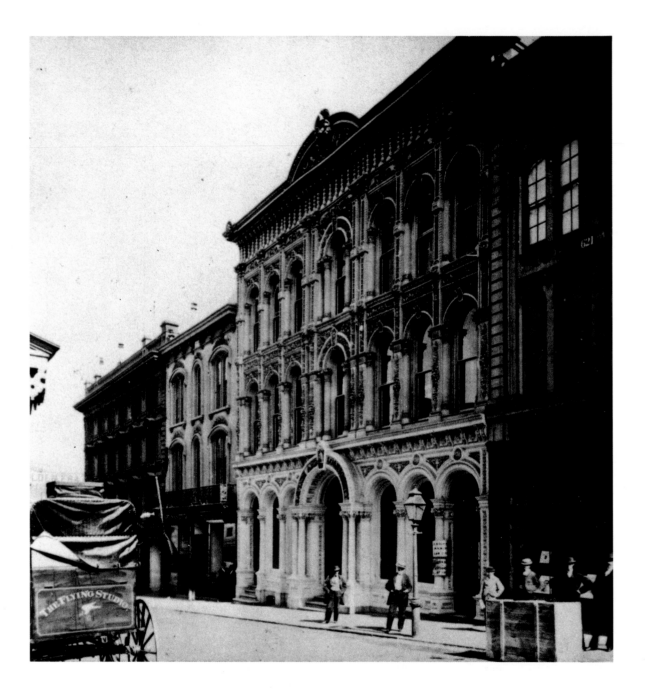

Eadweard Muybridge
Savings and Loan Society, c. 1870
Half-frame stereograph

Introduction

For more than a century, the city of San Francisco and the art of fine photography have been linked. The very discovery of photographic processes, in France and England in 1839, coincided closely with the origins of San Francisco's own modern history during the Gold Rush ten years later. From the first, the dynamic city at the Golden Gate was a magnet for great photographers. And thanks to its natural beauty and endless social ferment, it has remained one ever since, establishing a photographic tradition equaled by almost no other American community.

That tradition makes it possible to weave San Francisco's history into the larger history of photography itself—to assemble a visual tale of the city as told by several generations of artists who were drawn to it.

Some of these artists are best known for their innovative aesthetics, and others for the documentary photography emphasized here. What connects them is a persistent independence of vision that animates their work.

As early as January 1849, itinerant daguerreotypists were at work in the city, setting up their tripods in the muddy frontier that led to the Sierra goldfields. By the mid-1850s, such pioneers as James Ford, George Robinson Fardon, George S. Lawrence and Thomas Houseworth had opened permanent studios. They were soon joined by two seminal photographers of nineteenth-century America: Eadweard Muybridge and Carleton Watkins, who launched their notable careers from storefronts on Montgomery Street, today the heart of San Francisco's financial district.

Muybridge won a contemporary following with his views of the California wilderness, though he is perhaps best remembered for his sequenced studies of animal and human locomotion, which contributed profoundly to the development of the motion picture. (He became legendary in San Francisco in a less attractive context—fatally shooting the lover of his young wife, Flora, whose 1872 portrait by Muybridge appears in these pages.) Watkins, also among the premier landscape artists of the West, sharing Muybridge's enthusiasm for the Sierra's awesome Yosemite Valley, which he photographed time and again. Both men captured hundreds of San Francisco scenes in the city's youth, five of which appear in this volume.

Most of Carleton Watkins's San Francisco negatives, sadly, were lost in the fire that swept the city after the devastating earthquake of 1906, a catastrophe vividly documented by a German immigrant named Arnold Genthe who, in the 1890s, used a concealed camera to photograph the people of San Francisco's Chinatown. An intellectual with considerable personal charm, Genthe was a proponent of romantic portraiture and later gained recognition as a leading photographer of many writers, dancers, and other socially prominent figures.

For some sixty years, opening in the decade before Genthe's exploration of Chinatown, and extending into Franklin Roosevelt's New Deal, Gabriel Moulin was to San Francisco what Boswell was to Johnson—a chronicler so untiring that his work exceeds all others in its breadth and completeness. As the title of his own book, *Creation of a City*, implies, Moulin knew firsthand the people and events that transformed the rough-and-tumble western town into a great metropolis. He attended the international expositions of 1894 and 1915; was present at the 1906 earthquake, and watched the Golden Gate and Bay bridges rise thirty years afterward; he memorialized Nob Hill's mansions and their inhabitants for posterity. (Moulin's sons Irving and Raymond followed in his footsteps; today, more than a century after he began, Moulin's studio continues under the direction of his grandson, Thomas.)

When Gabriel Moulin published his Panama Pacific Exposition photographs in 1916, San Francisco native Ansel Adams was a fourteen-year-old mastering his first box camera. That same year he made his first exposure in the Yosemite Valley; ultimately he would acquire a reputation for dramatic wilderness photography that surpassed that of his predecessors Muybridge and Watkins. Adams's 1918 view of Helmet Rock at Land's End, the westernmost tip of the San Francisco peninsula, foreshadows his extensive career as a camera-equipped naturalist.

Adams, with Willard Van Dyke and Edward Weston, was a founding member in 1932 of ƒ/64, a group of California photographers who rejected the soft-focus and impressionistic techniques of fine-art pictorialism in favor of intense, straightforward realism. Another member was Imogen Cunningham, a familiar local figure in San Francisco from 1917 until her death in 1976. Cunningham, who had studied in Washington with Edward S. Curtis, the preeminent photographer of the American

Indian, went on to redefine the limits of portraiture as a leading exponent of modern photography on the West Coast.

Straightforward realism of a more confrontational sort inspired the work of Dorothea Lange. Lange began her career in 1914 with a camera presented by her teacher—Arnold Genthe—but it wasn't until the thirties that she developed a distinctive point of view, embodied in some of the most compelling images of the Great Depression. Working in the politically charged atmosphere that characterized San Francisco in those years, Lange photographed people in the social contexts that bound their fates. When she wasn't focusing on urban breadlines, she was out in California's agricultural valleys, collecting a powerful and much-acclaimed visual record of rural poverty for the federal Farm Security Administration.

In the same period, the German-born John Gutmann was discovering the nooks and crannies of American popular culture. He photographed athletic games, parades, graffiti, automobiles, and other everyday events and artifacts with the fresh eye and wonder of a newcomer. Trained as a painter in Europe, Gutmann employed unusual angles and compositions in these photographs, to forge a novel avant-garde documentary style. A lifelong teacher as well as an innovative artist, in 1946 he helped establish the photography department of San Francisco State College (now California State University at San Francisco).

Minor White also combined teaching with photographic experimentation. A cofounder with Ansel Adams in 1946 of yet another influential photography program, at the California School of Fine Arts (today the San Francisco Art Institute), he systematically documented the city streets in the postwar 1940s. Promoting photography as a means of spiritual self-exploration, White later became the guru for a whole generation of young artists.

A similar role, primarily in the realm of words, fell to Allen Ginsberg. Almost incidentally, this poet laureate of the Beat movement took photographs of his fellow writers, not as a camera professional, but as an insider whose personal snapshots offer some of the best pictures we have of the beatnik fifties. A decade later, as bohemia exchanged the beatniks for the hippies, participant-observer Elaine Mayes turned her lens in appalled fascination on the child-mothers and free spirits of Haight-Ashbury's emerging culture.

At the onset of the sixties, San Francisco State's graduate photography department was experiencing a burst of new energy under the leadership of Jack Welpott. Insisting that aesthetic experiments in photography must be carried out with technical skill, especially in the darkroom, Welpott attracted a coterie of extraordinarily talented students. Under his inspiration, several of them formed a group called the Visual Dialogue Foundation in 1969, which organized exhibitions and reinforced San Francisco's importance in the world of fine photography. Los Angeles-raised Judy Dater, who moved north to study with Welpott in 1963, has since emerged as a major force in her own right, noted for her revealing feminist portraits.

A survey of artists' views of San Francisco cannot depend exclusively on photographers who made the city their home. Familiarity is just one route to seeing well; at their best, the perceptions of those who are only passing through may be more penetrating and objective than the native's. The beautiful and formal cityscapes of Frank Gohlke are cases in point, as are the wry, quick-witted observations of Lee Friedlander and Garry Winogrand.

If one can generalize about the latest chapter in San Francisco's venerable photographic history, it is to note that young artists today are often to be found on long-term, highly focused projects. Catherine Wagner, for example, carefully documented the construction of the city's sprawling George Moscone Convention Center in the early eighties, and is now at work on a comprehensive look at classroom interiors. Under the auspices of the American Institute of Architects, a number of other artists were commissioned to photograph San Francisco's Civic Center area in 1985. Laura Volkerding, John Harding, and Bill Dane were among the project's participants, who were given free rein to picture the district as they chose.

To collapse nearly a century and a half of images into one hundred pages is to provide just a selective glimpse of San Francisco's evolution, and of the impact it had on sixty or so of the many artists who have photographed it. But like San Francisco itself, these selections are exceptionally seductive. They speak, with intensity and grace, of a city that has held a unique place in the world's imagination—and in its visual imagery—since the first daguerreotypists carried their equipment ashore at the Golden Gate in 1849.

—R. S.
1986

San Francisco Observed

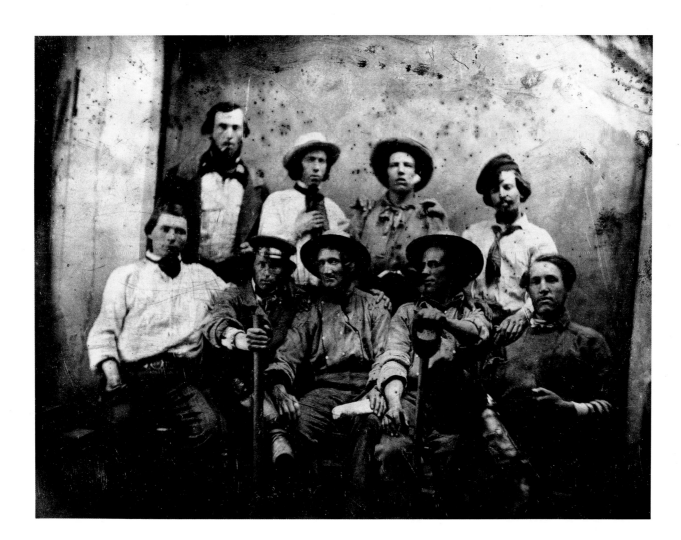

Anonymous
Goldminers, c. 1850
Daguerreotype

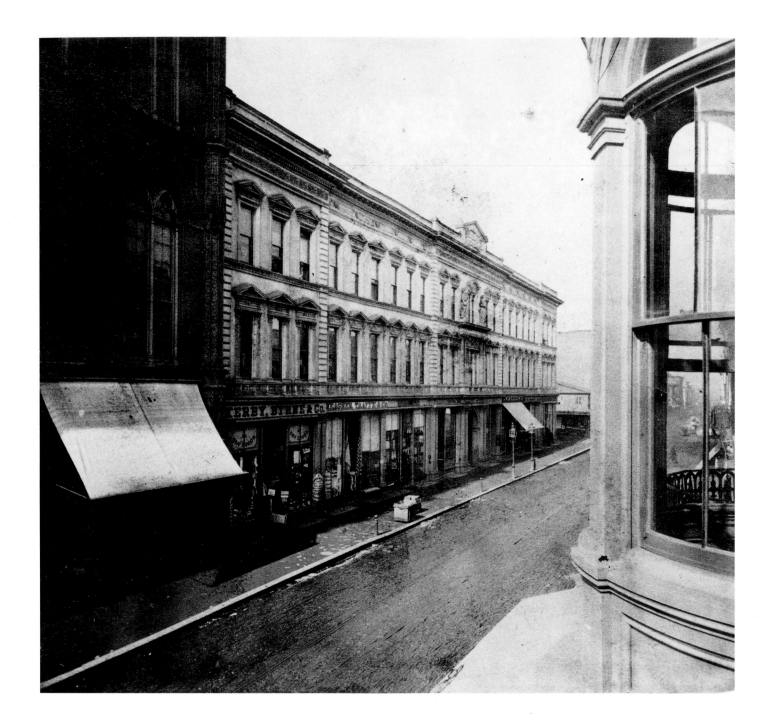

George S. Lawrence and Thomas Houseworth
Lick House from Michel's Building, corner Market and Montgomery streets, 1866

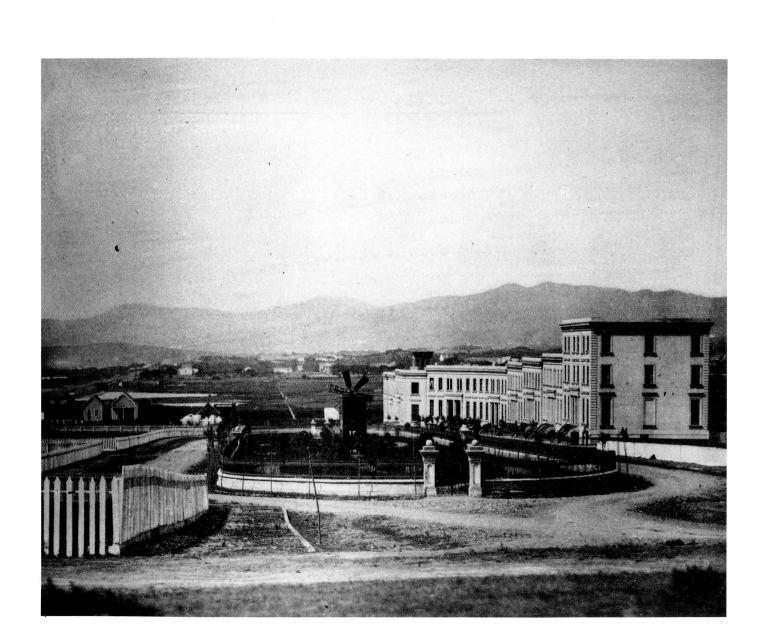

George Robinson Fardon
"**South Park from 2nd Street**" from <u>**San Francisco Album**</u>**, Photographs of the Most Beautiful Views & Public Buildings of San Francisco, 1856**

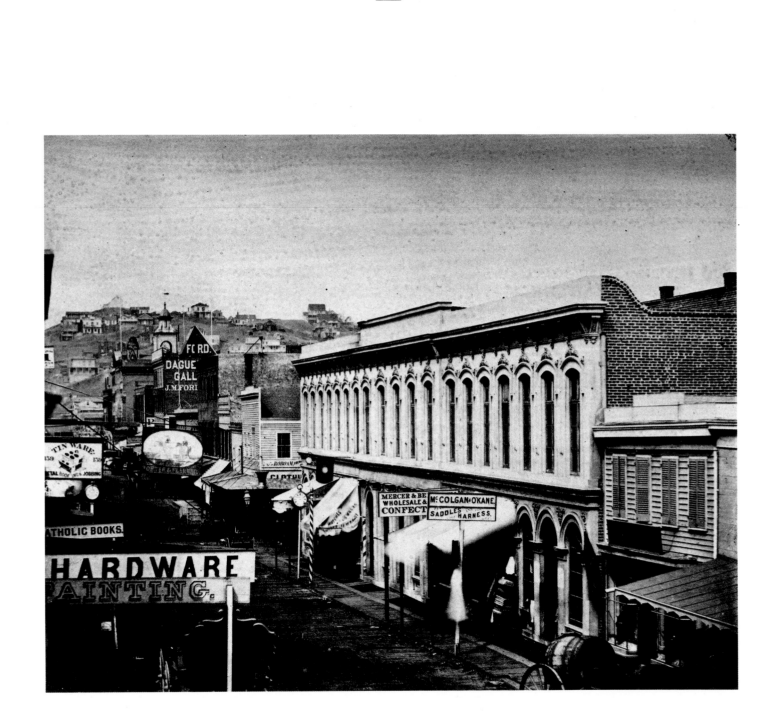

George Robinson Fardon
"Kearney Street near Sacramento" from San Francisco Album, Photographs of the Most Beautiful Views & Public Buildings of San Francisco, 1856

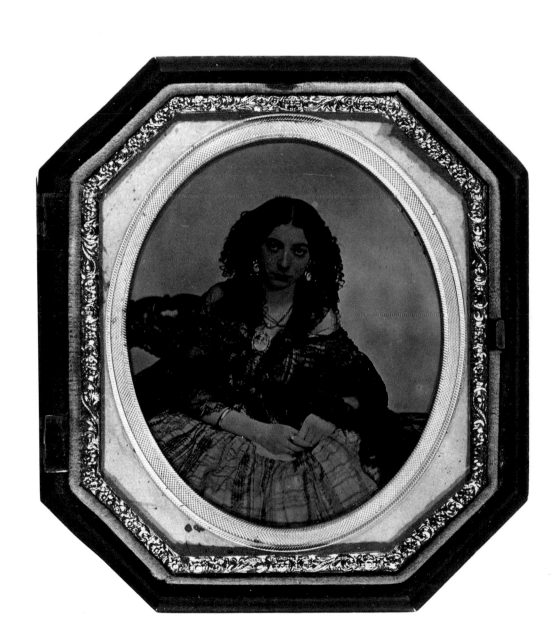

Anonymous
Lola Montez, c. 1854
Ambrotype

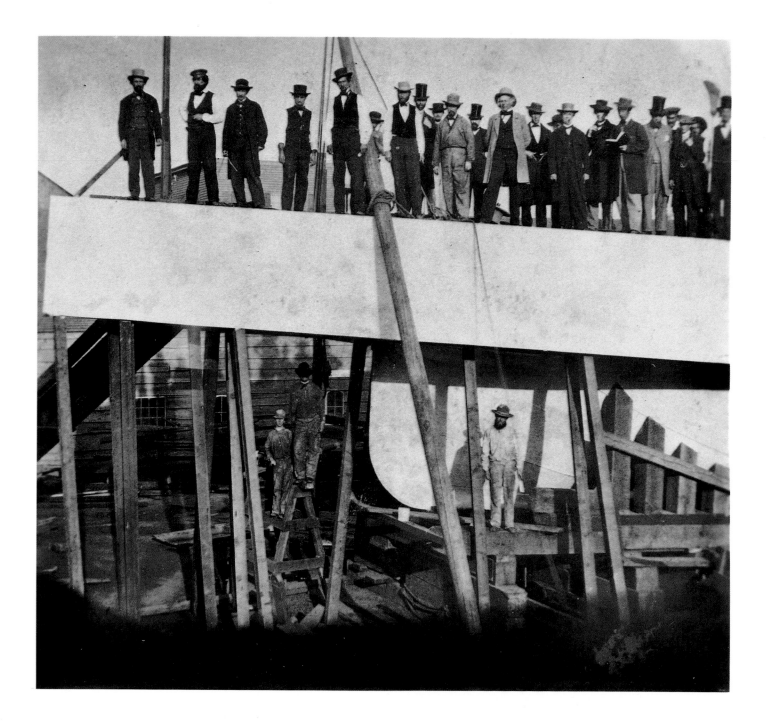

George S. Lawrence and Thomas Houseworth
The Ram of Monitor Camanche, 1866

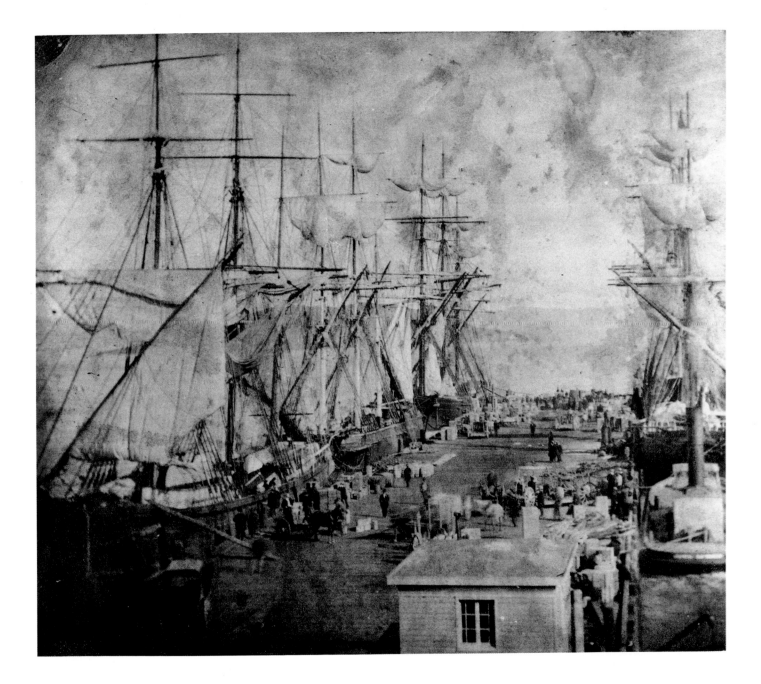

George S. Lawrence and Thomas Houseworth
Vallejo Street Wharf, 1866

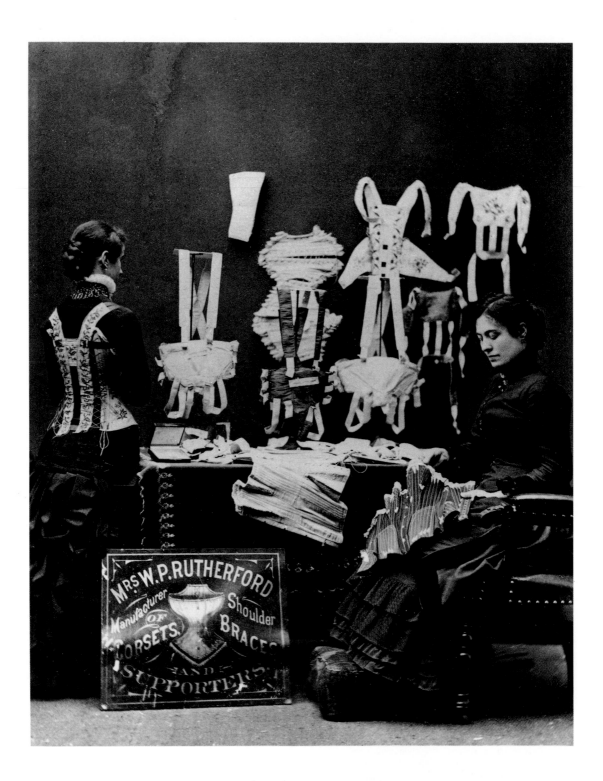

Isaiah West Taber
"Mrs. W. P. Rutherford and Corsets" from <u>The Taber Photographic Album</u>, San Francisco, 1880

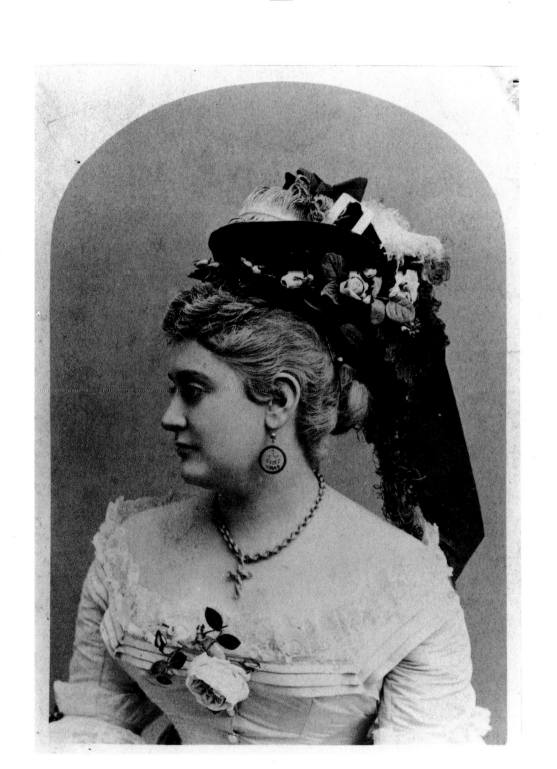

Eadweard Muybridge
Flora Muybridge, c. 1872

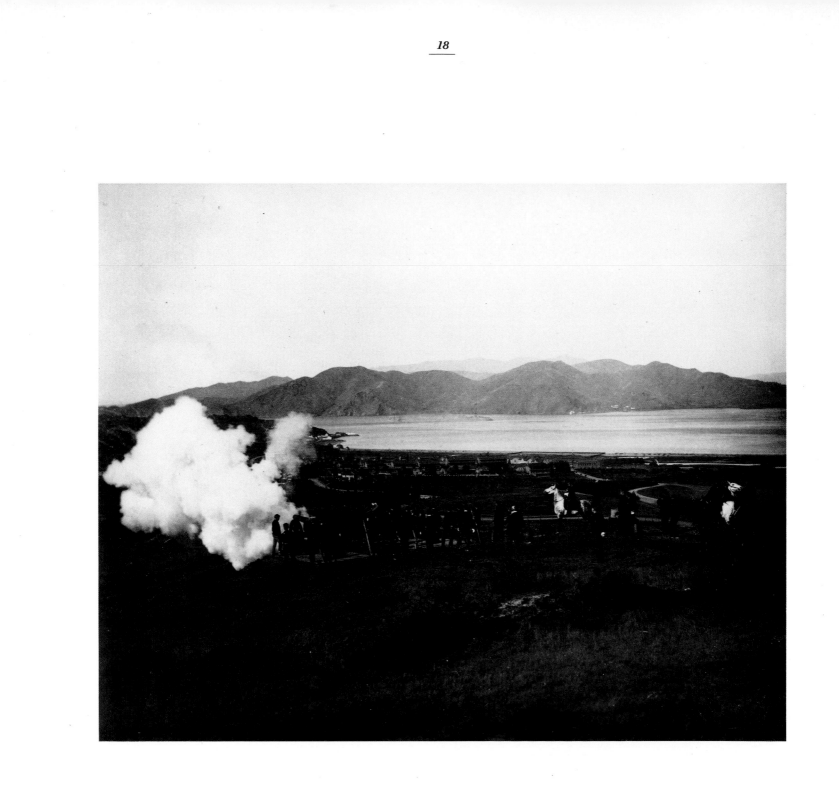

Carleton Watkins
Artillery Practice, Presidio, c. 1876

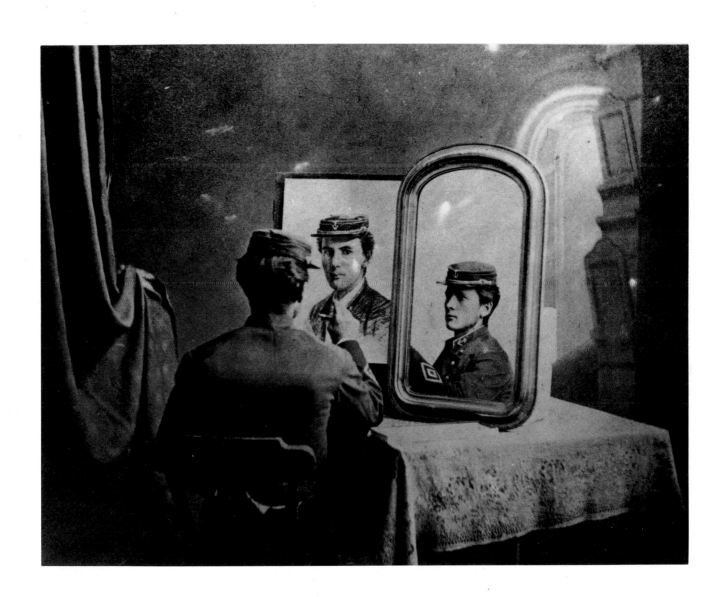

Dr. Albert A. Michelson, Nobel Prize Winning Physicist, Self-portrait as a Midshipman, c. 1873

Anonymous
Jack London with His Dog Rollo, 1886

Anonymous
Bret Harte, c. 1885

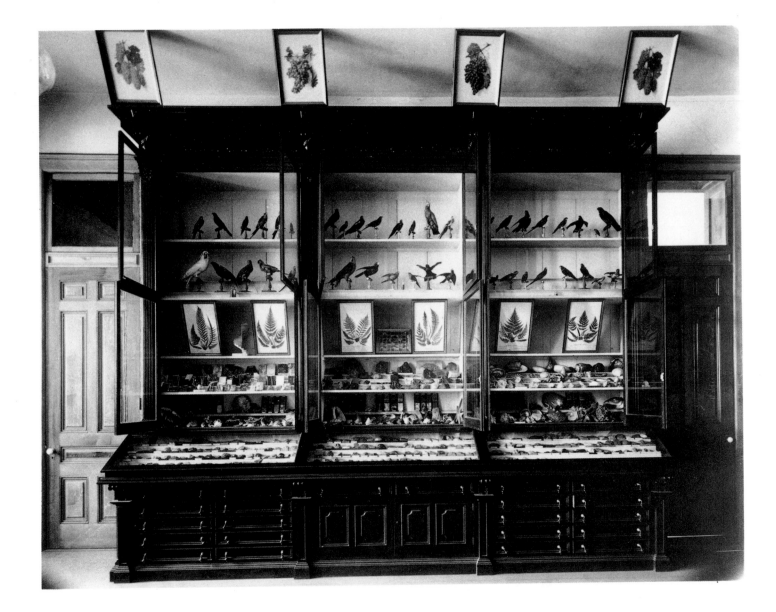

Carleton Watkins
St. Ignatius College Museum (Mineralogy and Ornithology), c. 1890

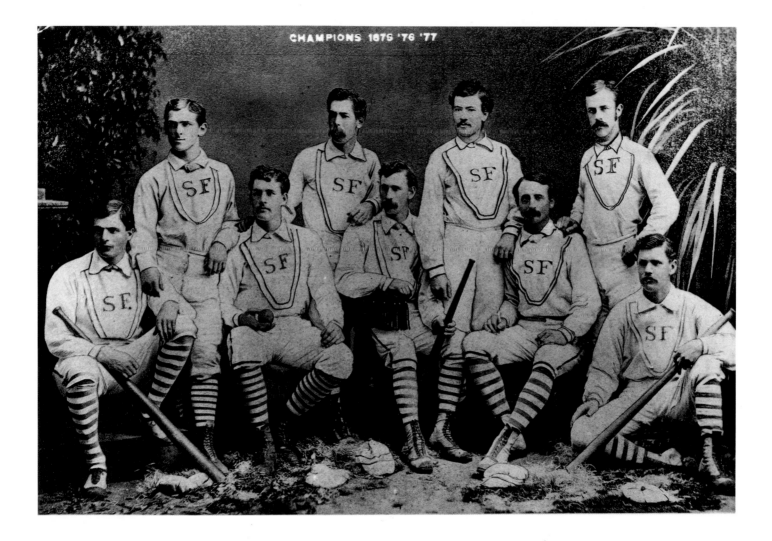

Thomas Houseworth
San Francisco Baseball Club of 1875

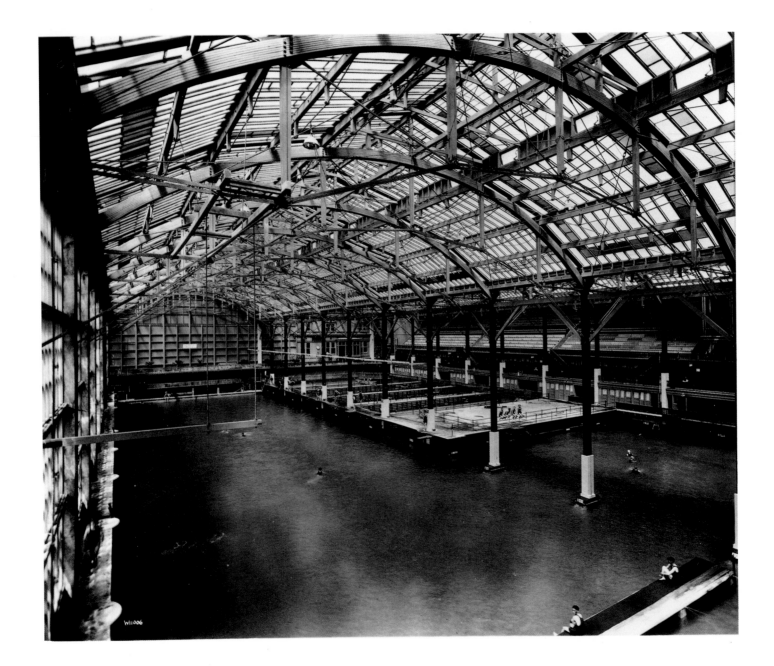

Lothers and Young Studios
Sutro Baths, n.d.

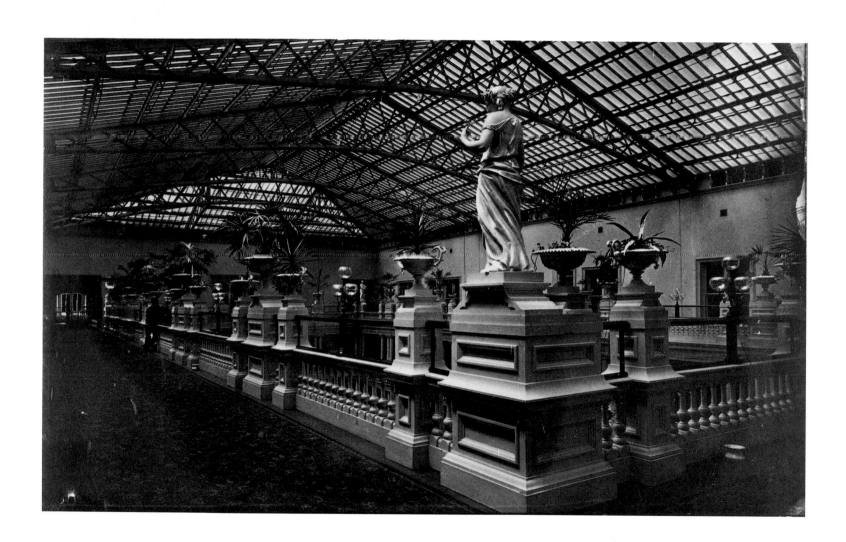

Isaiah West Taber
The Upper Corridor of the Palace Hotel, c. 1900

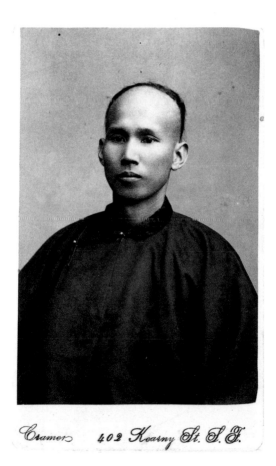

Cramer (Studio)
Chinese Man, c. 1900
Carte-de-visite

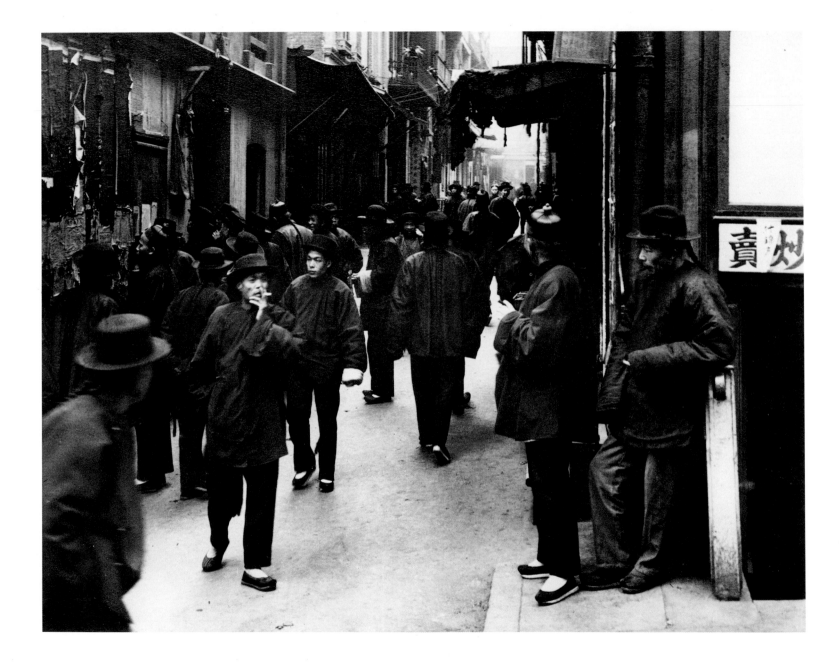

Arnold Genthe
Street of the Gamblers, 1895

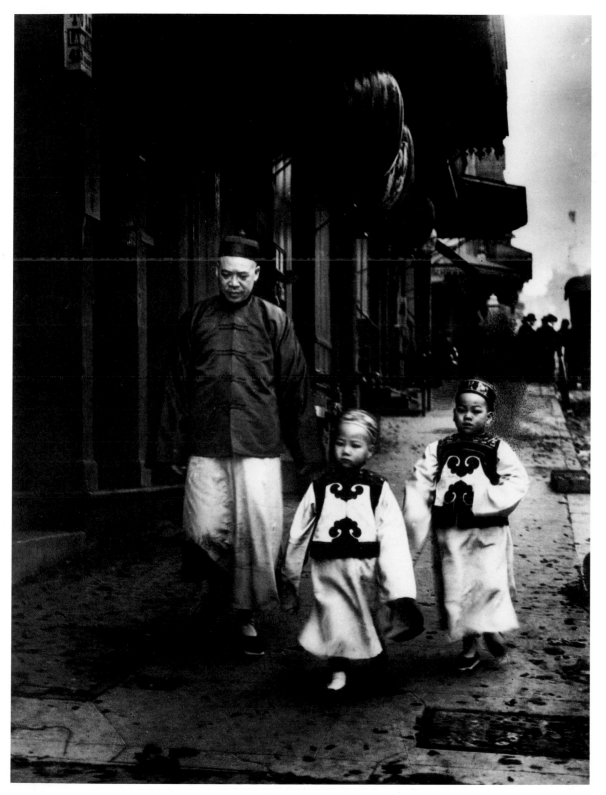

Arnold Genthe
Aristocrats of Chinatown, 1895

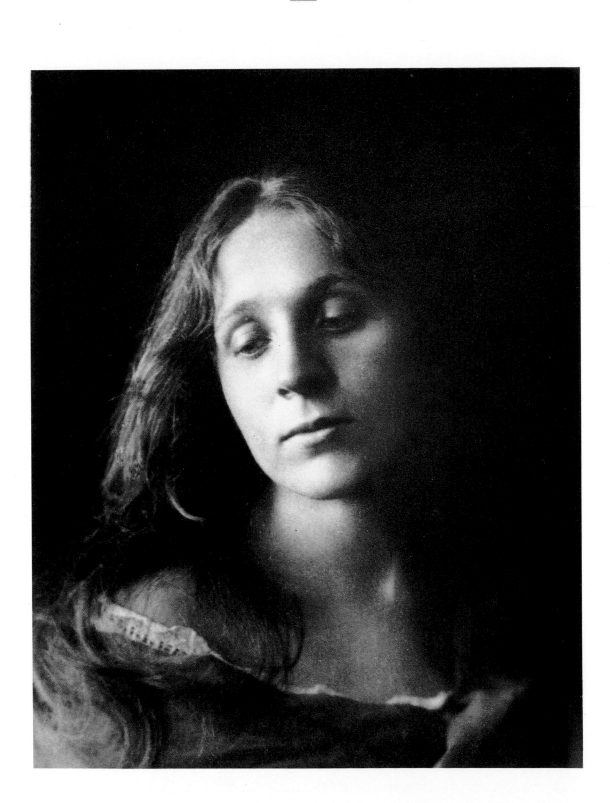

Laura Adams Armer
Portrait, c. 1905

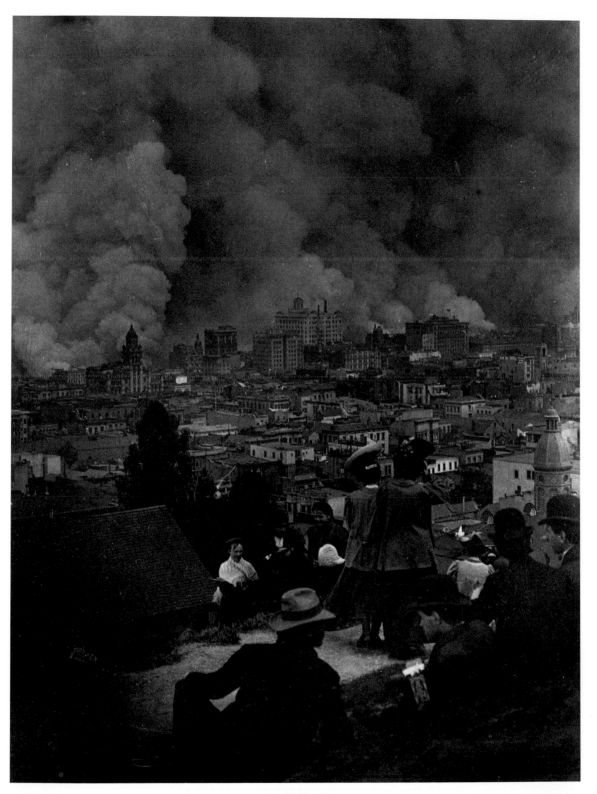

Arnold Genthe
Group Watching Fire from Hilltop, 1906

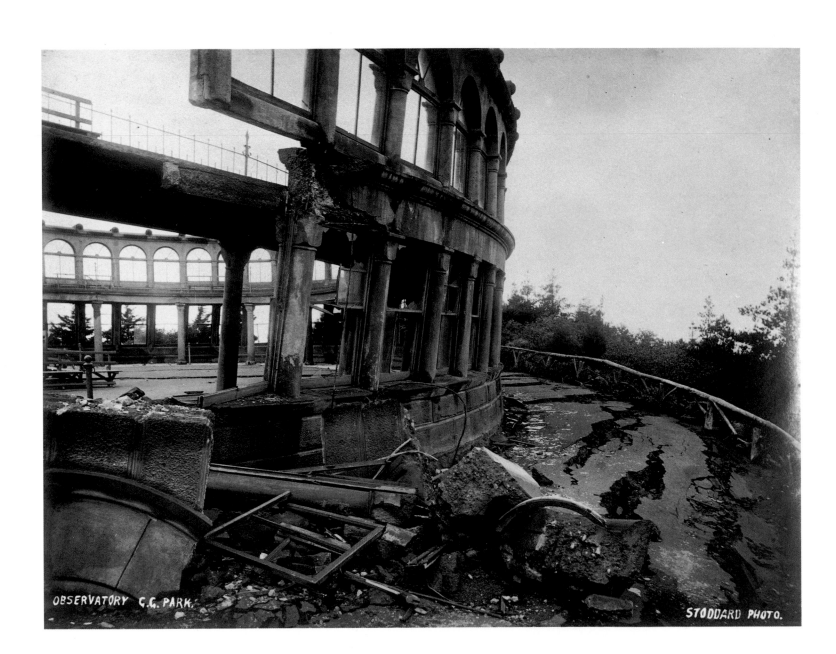

James Stoddard
"Observatory, Golden Gate Park," from <u>San Francisco Earthquake</u>, 1906

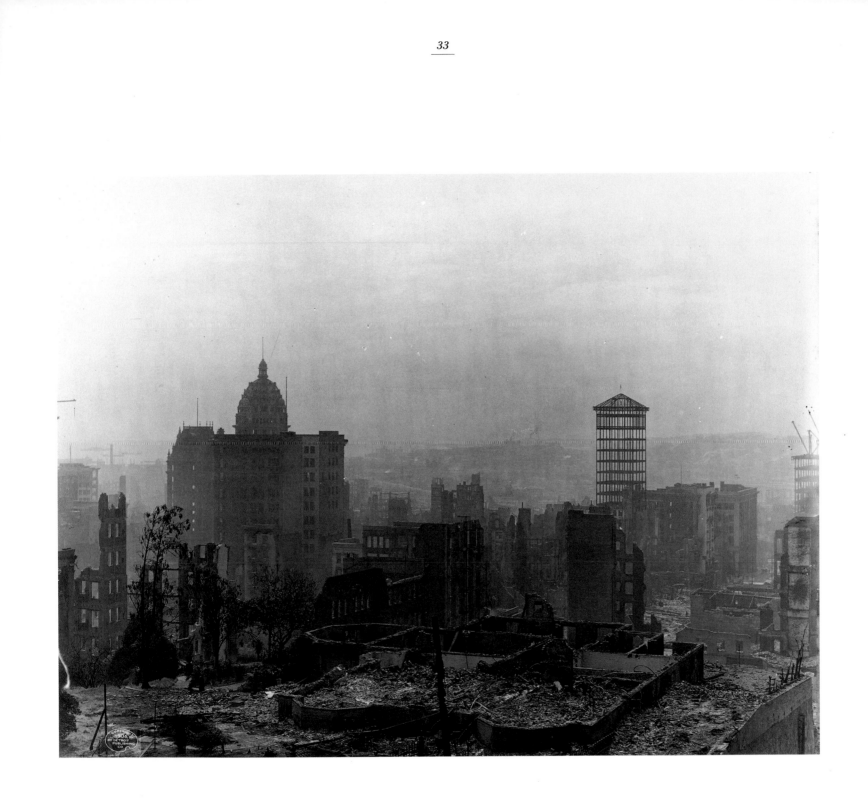

William Henry Jackson
San Francisco from Nob Hill after the Earthquake and Fire, 1906

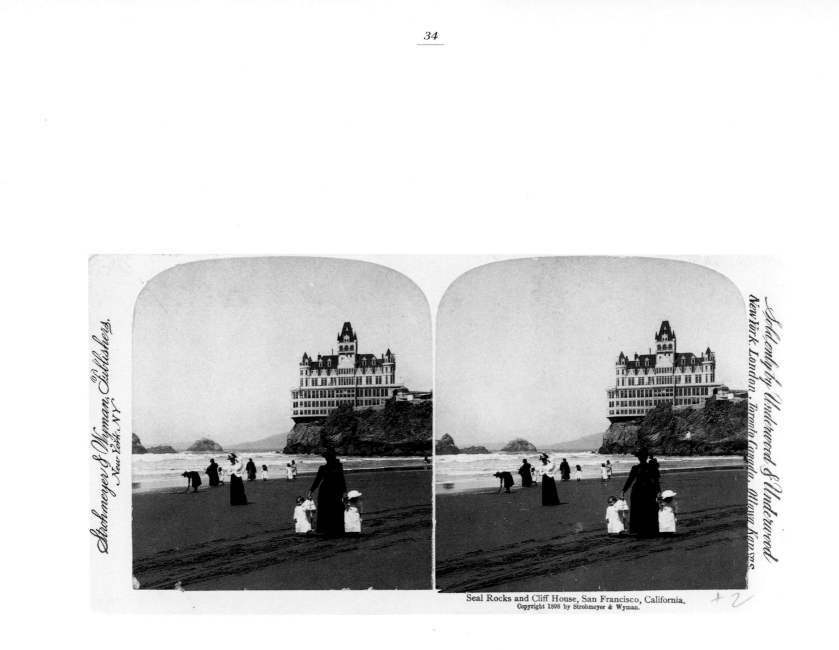

Seal Rocks and Cliff House, San Francisco, California.
Copyright 1898 by Strohmeyer & Wyman.

Strohmeyer and Wyman Publishers
Seal Rocks and Cliff House, 1898
Stereograph

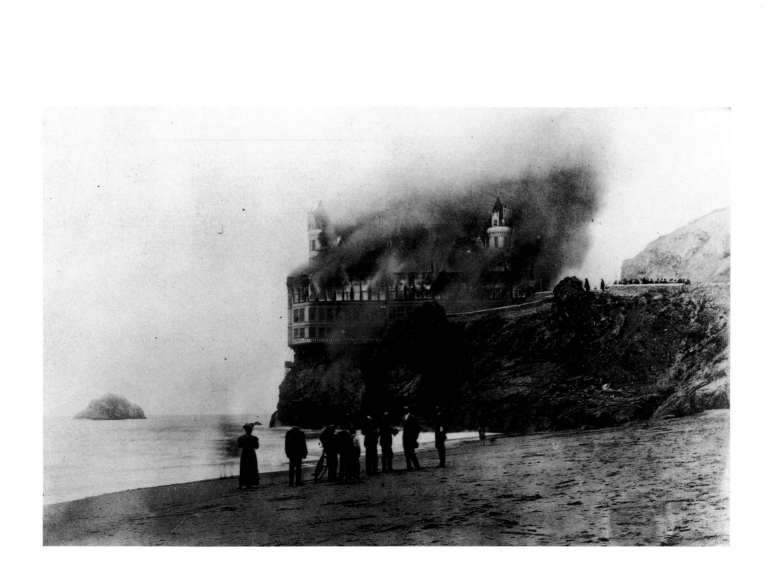

Anonymous
Cliff House, September 7, 1907
Postcard

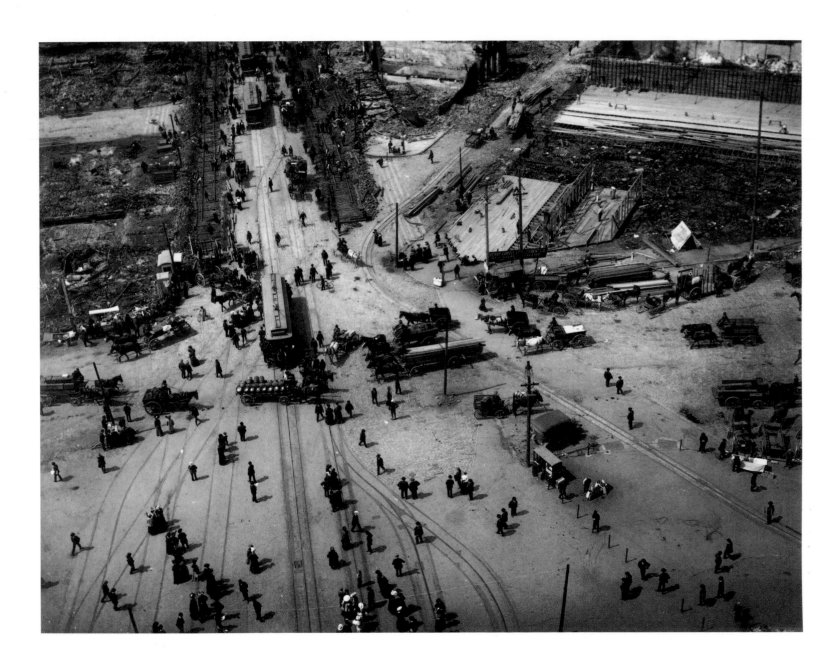

Anonymous
Looking up Market Street from the Ferry Building Tower, 1906

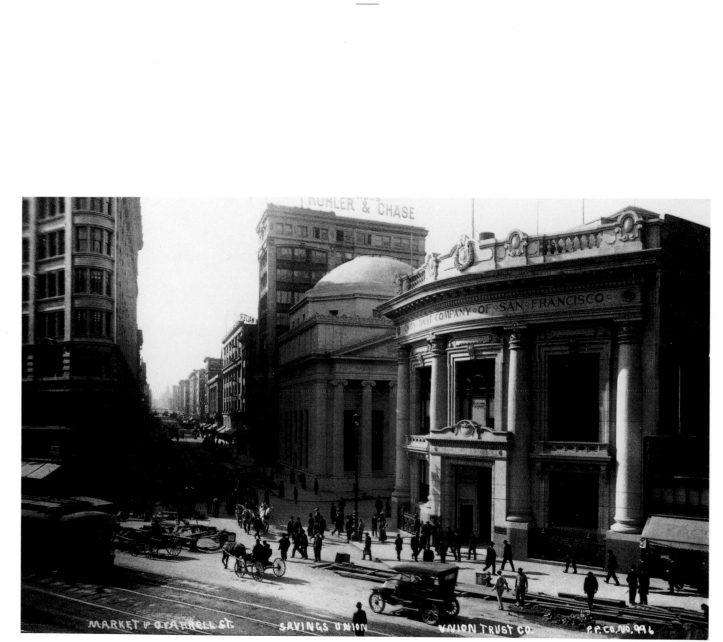

Pillsbury Picture Company
Market and O'Farrell, c. 1915
Postcard

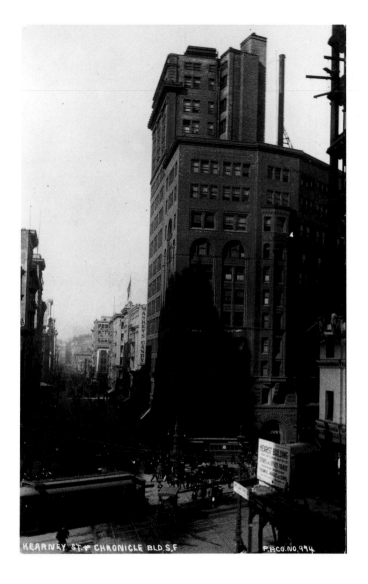

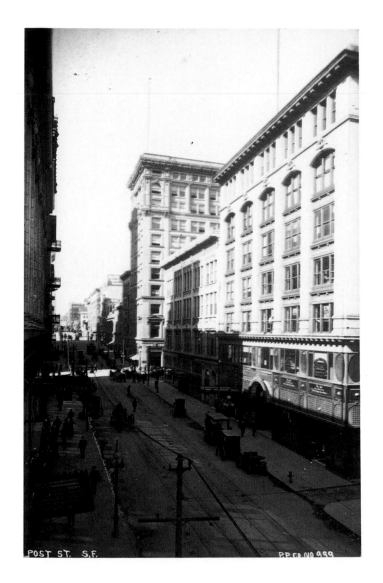

Pillsbury Picture Company
Chronicle Building, c. 1915
Postcard

Anonymous
Post Street, c. 1915
Postcard

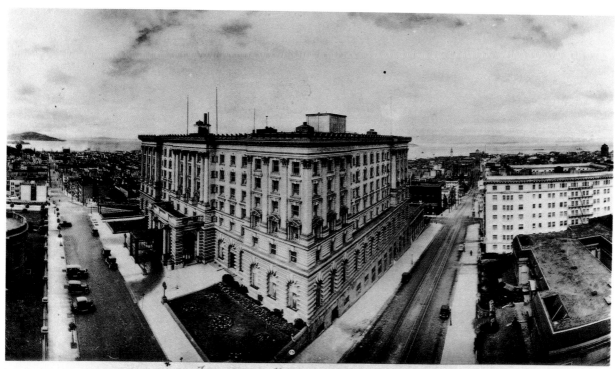

Fairmont Hotel San Francisco Cal.

R. J. Waters and Company
Fairmont Hotel, c. 1930
Postcard

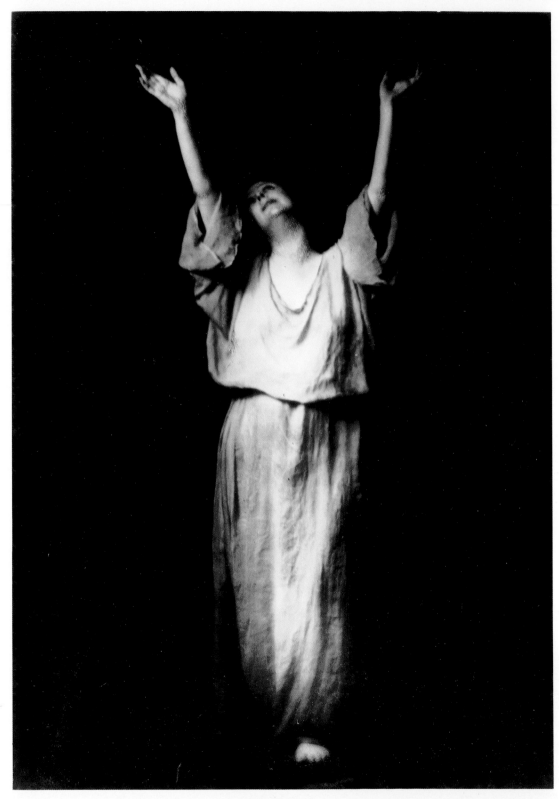

Arnold Genthe
Isadora Duncan, c. 1915

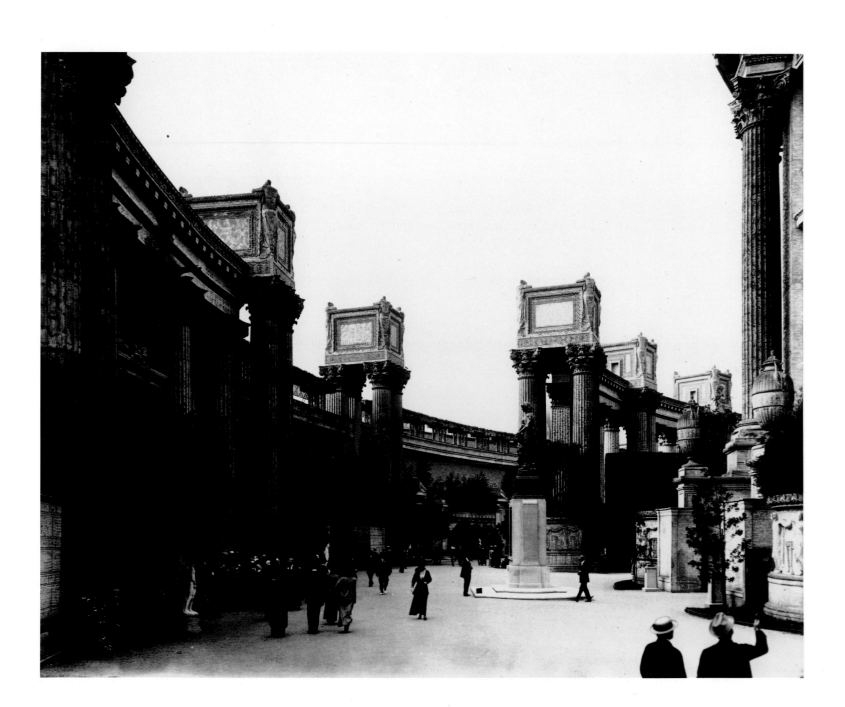

Gabriel Moulin
Palace of Fine Arts, Panama Pacific International Exposition, 1915

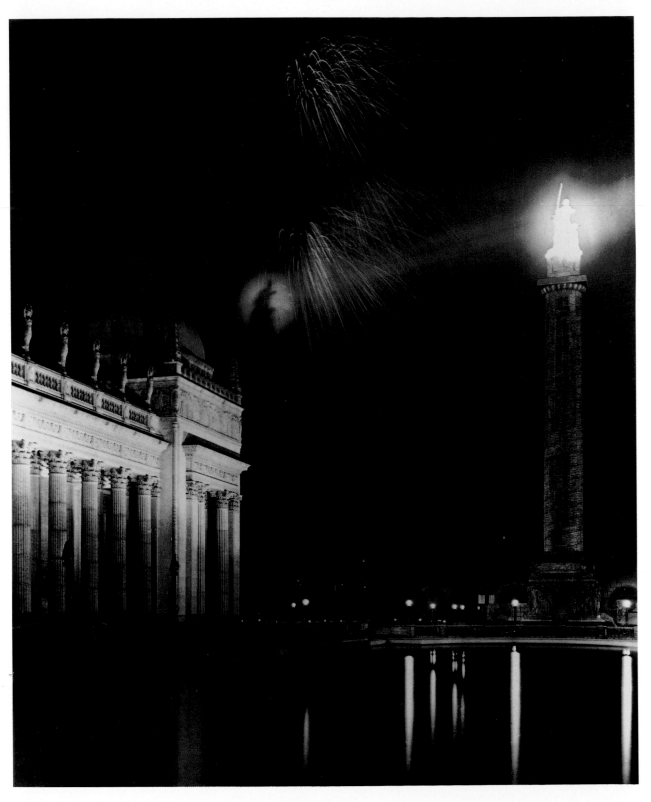

Gabriel Moulin
The Pool in the Central Courtyard, Panama Pacific International Exposition, 1915

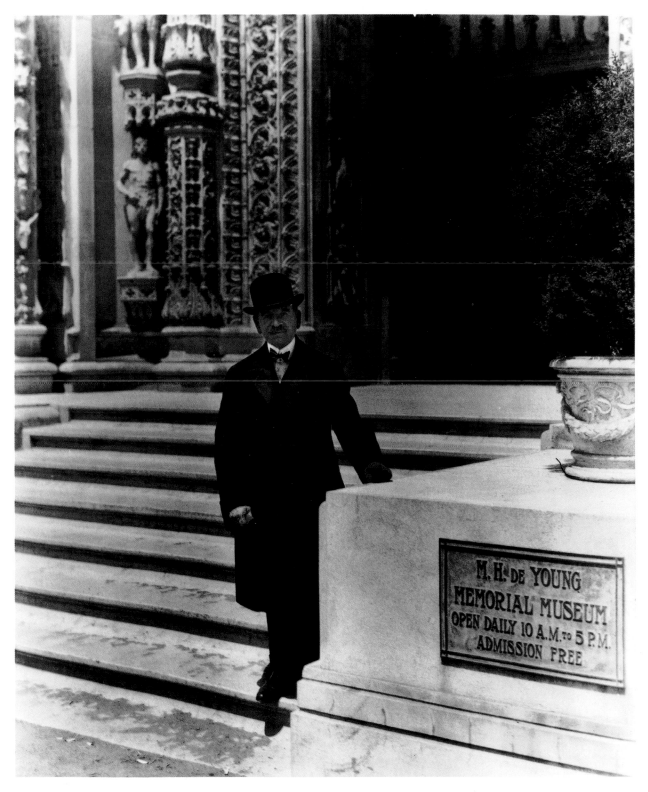

Gabriel Moulin
M. H. de Young at the M. H. de Young Memorial Museum, c. 1916

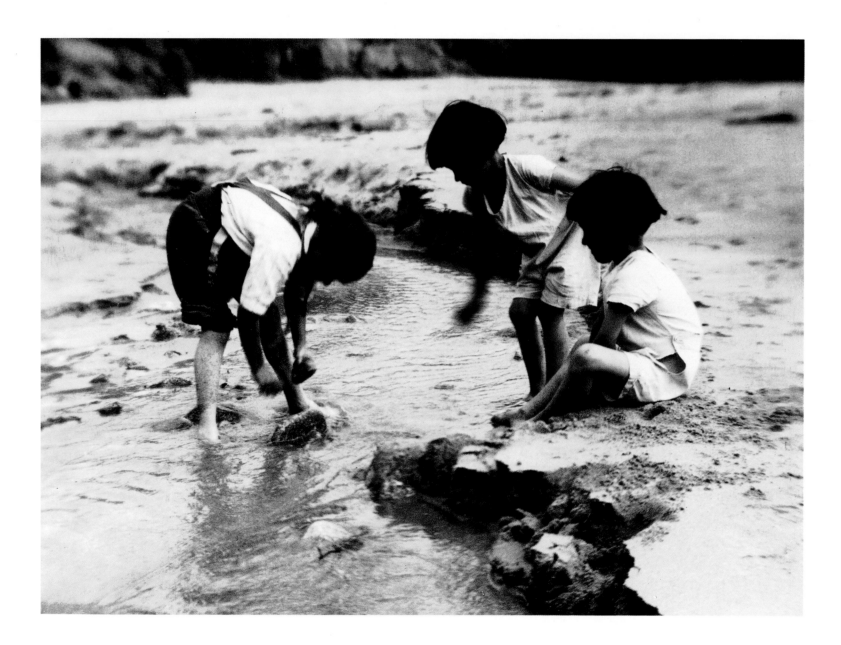

Imogen Cunningham
Boys at the Beach, 1922

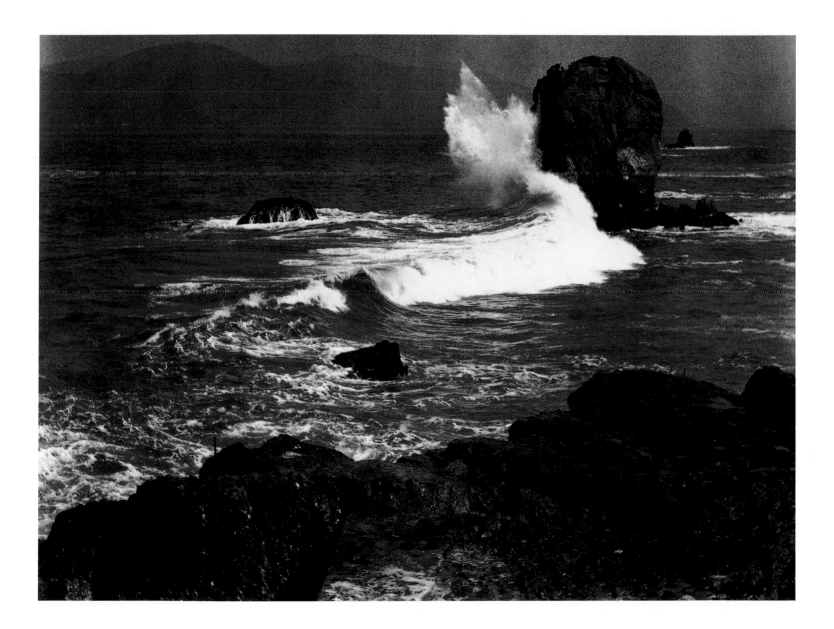

Ansel Adams
Helmet Rock, Land's End, San Francisco, 1918

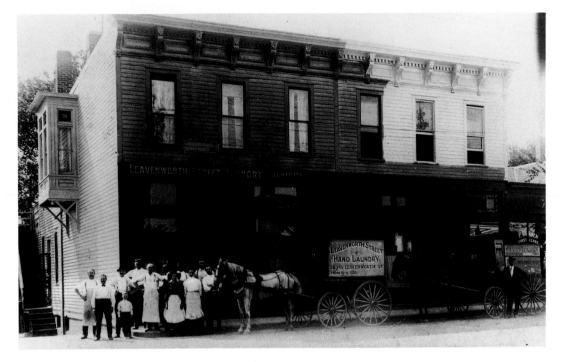

Anonymous
Leavenworth Street Hand Laundry, 1910
Postcard

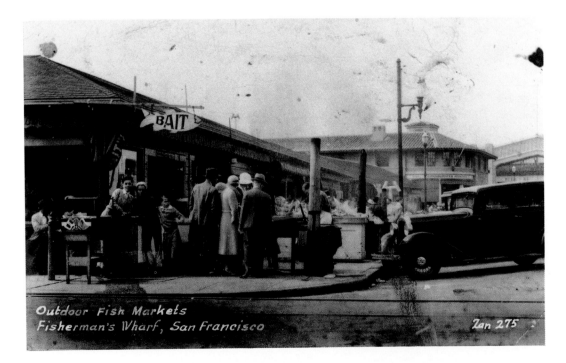

Anonymous
Fisherman's Wharf, c. 1929
Postcard

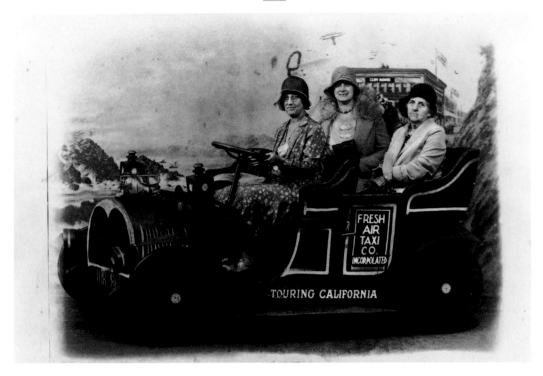

Anonymous
Touring California, c. 1920
Postcard

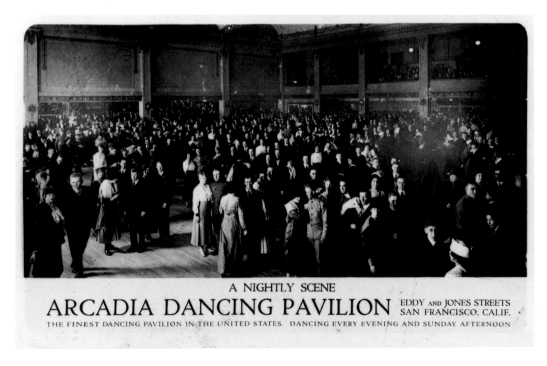

Anonymous
Arcadia Dancing Pavillion, n.d.
Postcard

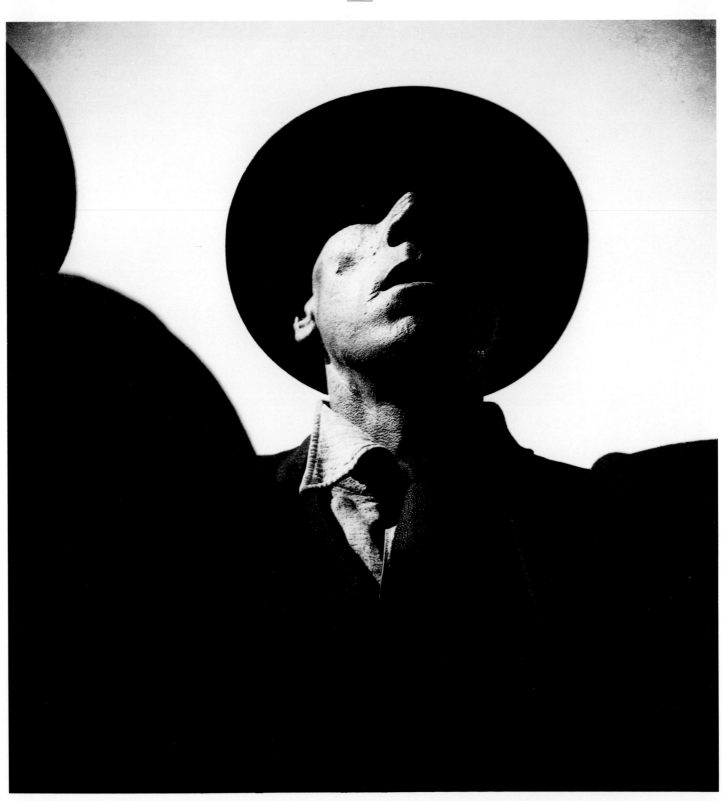

Dorothea Lange
Demonstration, 1934

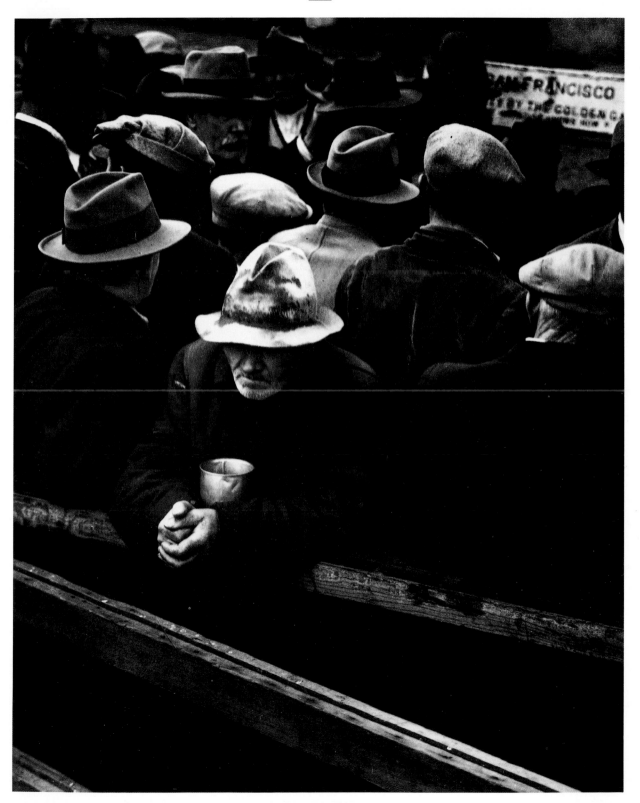

Dorothea Lange
White Angel Breadline, 1933

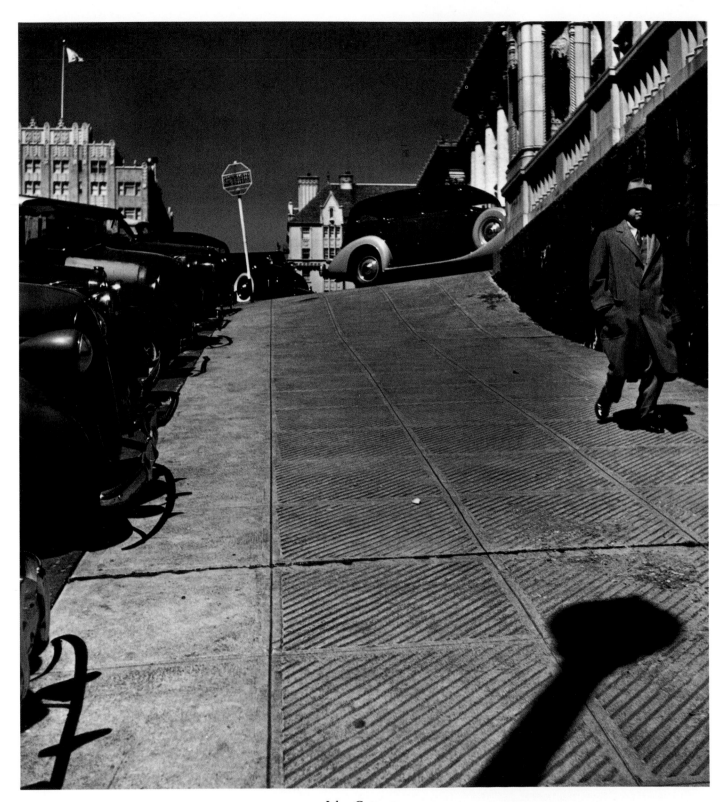

John Gutmann
Limousines into the Mark Hopkins, 1937

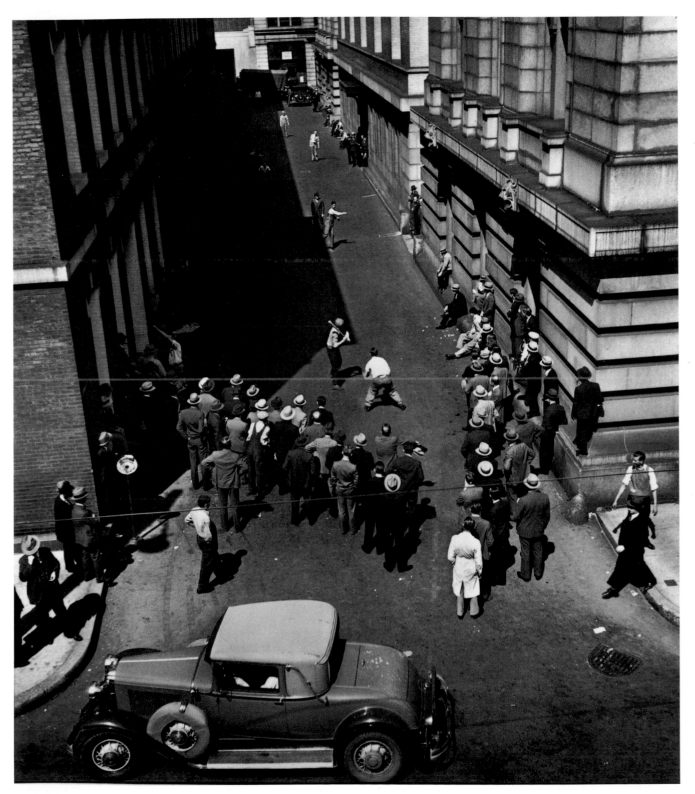

John Gutmann
Lunch Hour, 1934

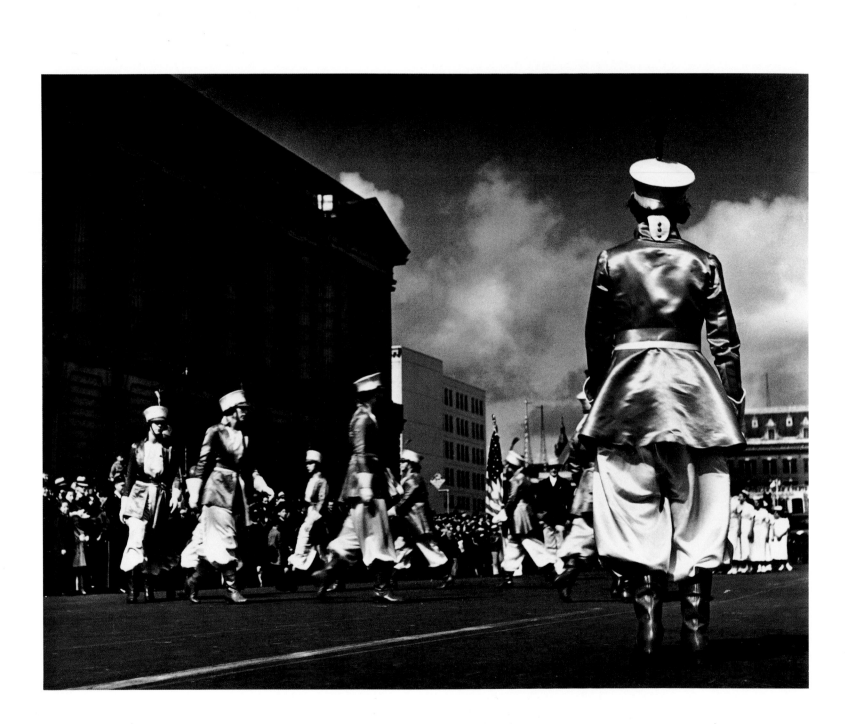

John Gutmann
Drill Team in Parade, 1935

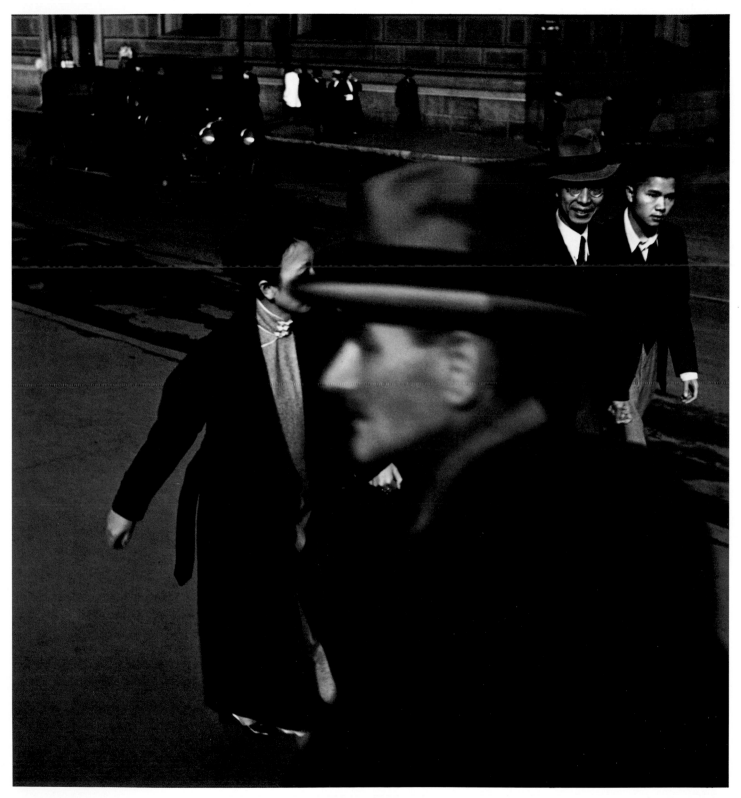

John Gutmann
Horse and Hand, 1935

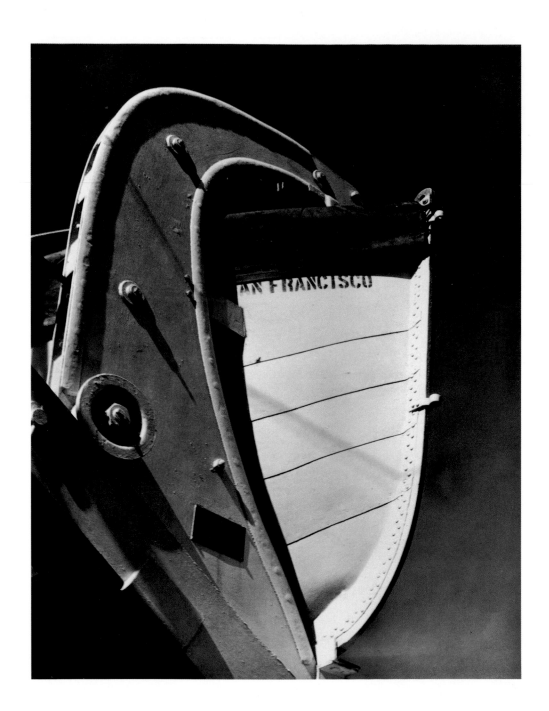

Willard Van Dyke
California Lifeboat, c. 1931

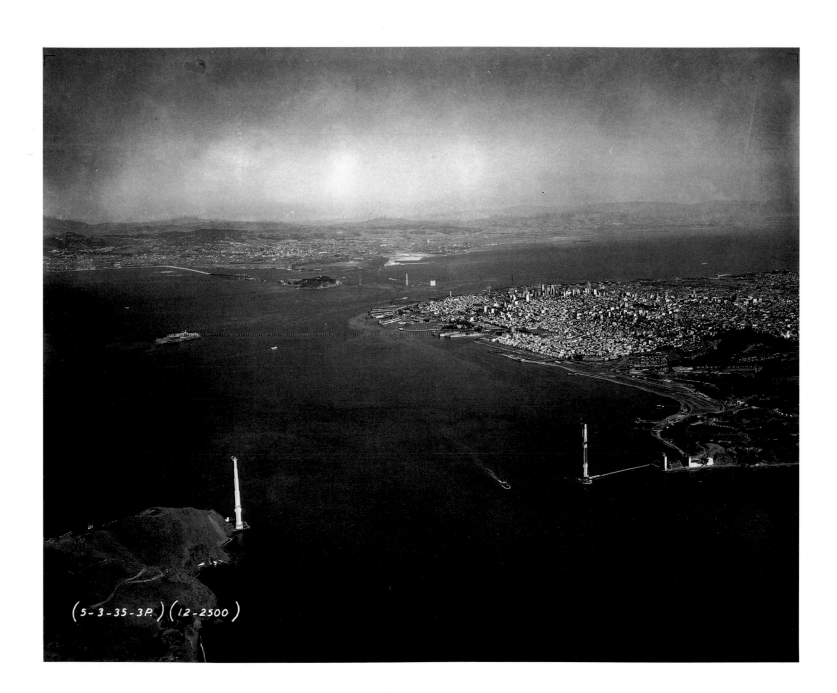

(5-3-35-3P.) (12-2500)

Gabriel Moulin
Towers of the Golden Gate Bridge, Summer 1935

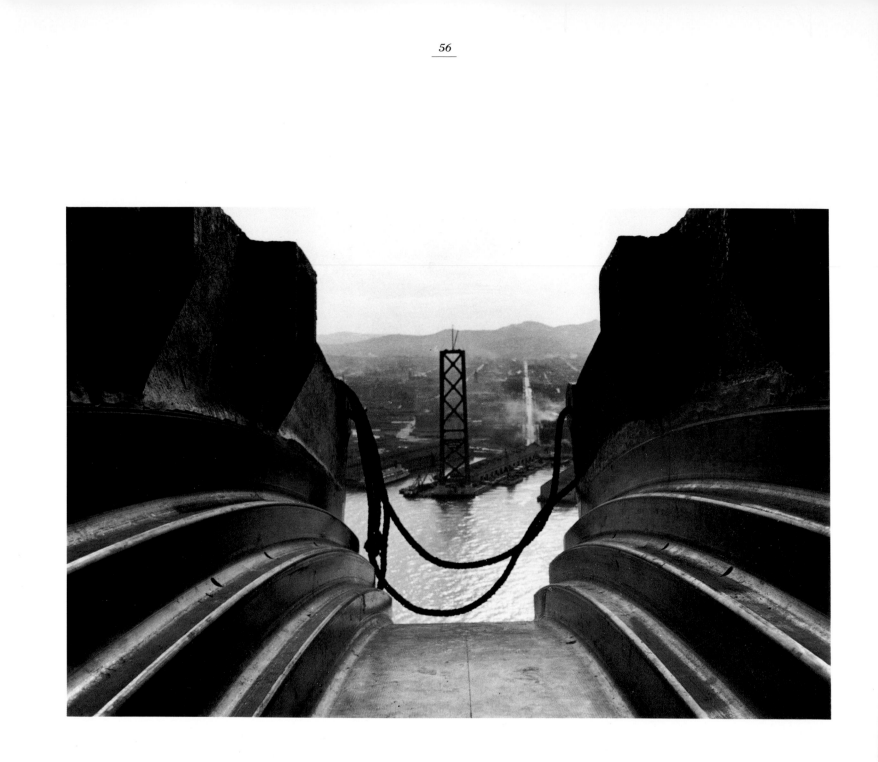

Peter Stackpole
San Francisco Waterfront Viewed through a Cable Saddle on Tower W3, 1935 (Bay Bridge)

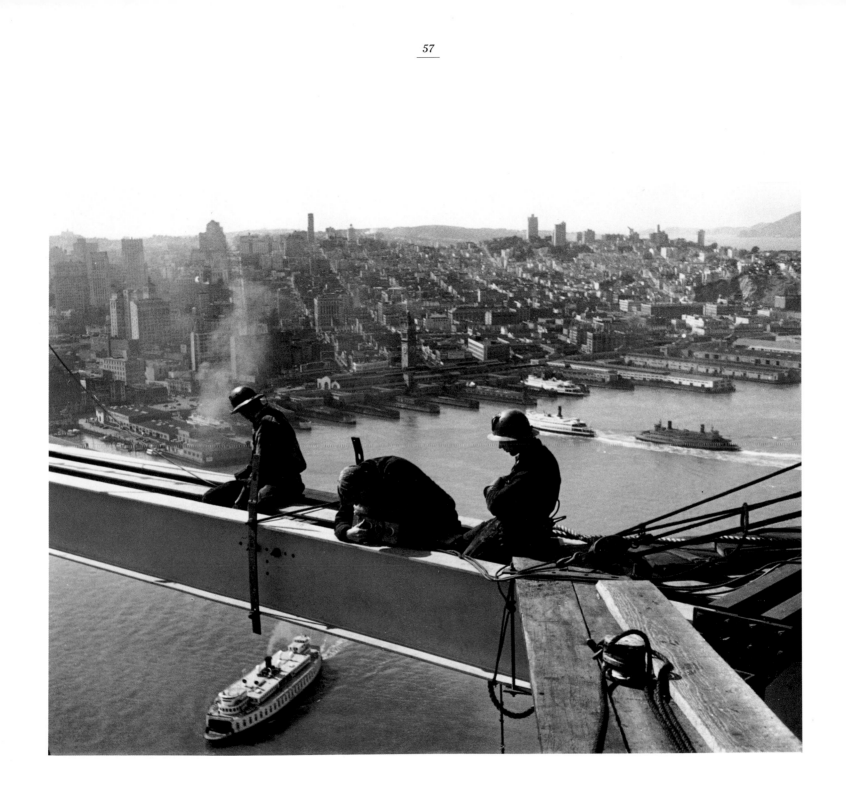

Peter Stackpole
Watching a Load of Rivets Coming Up against the Backdrop of San Francisco, 1935 (Bay Bridge)

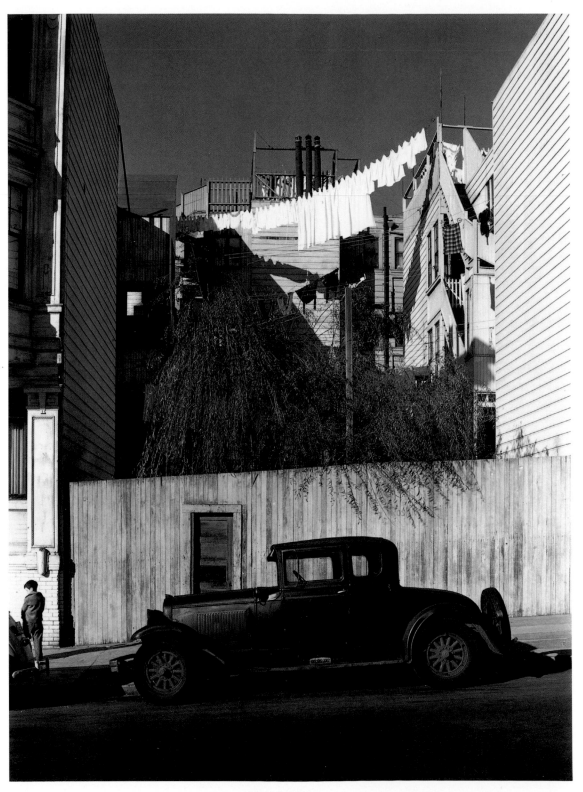

Ansel Adams
A Neighborhood, c. 1938

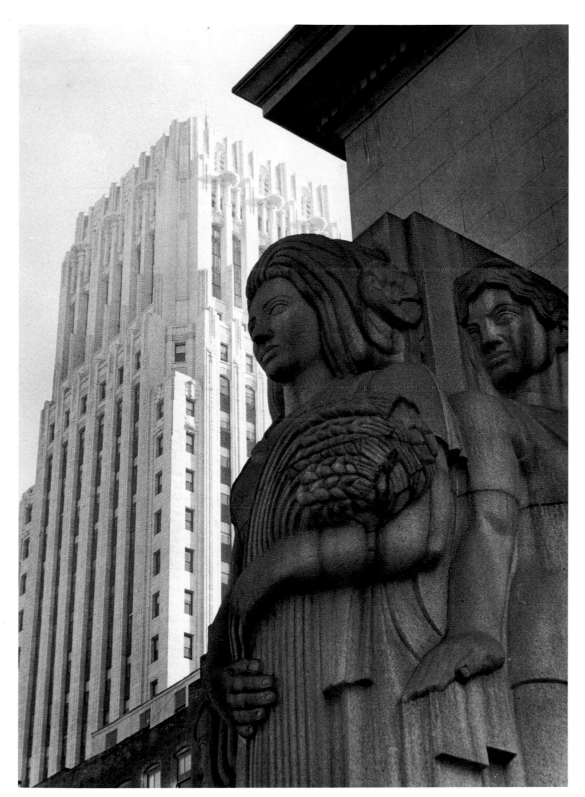

Edwin Rosskam
Telephone Building, 1939 from <u>San Francisco, West Coast Metropolis</u>

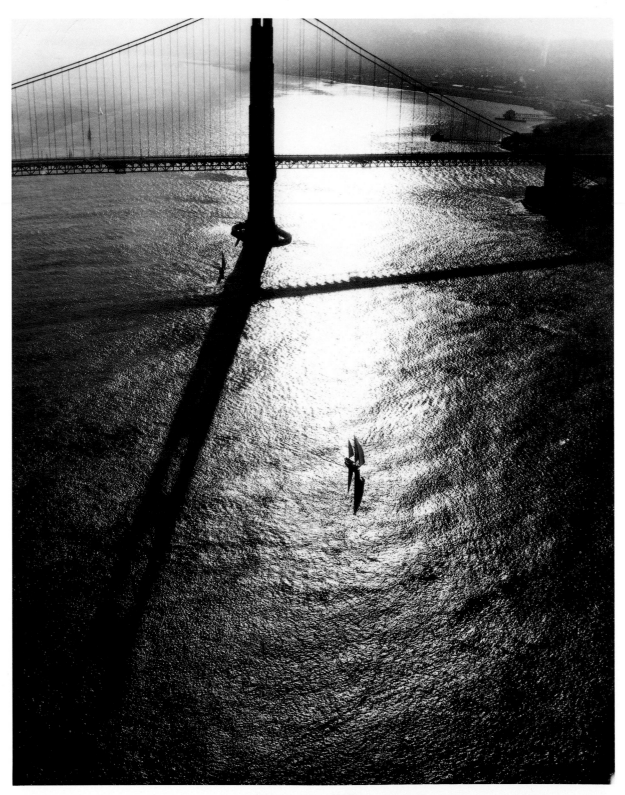

Margaret Bourke-White
San Francisco Bay, 1952

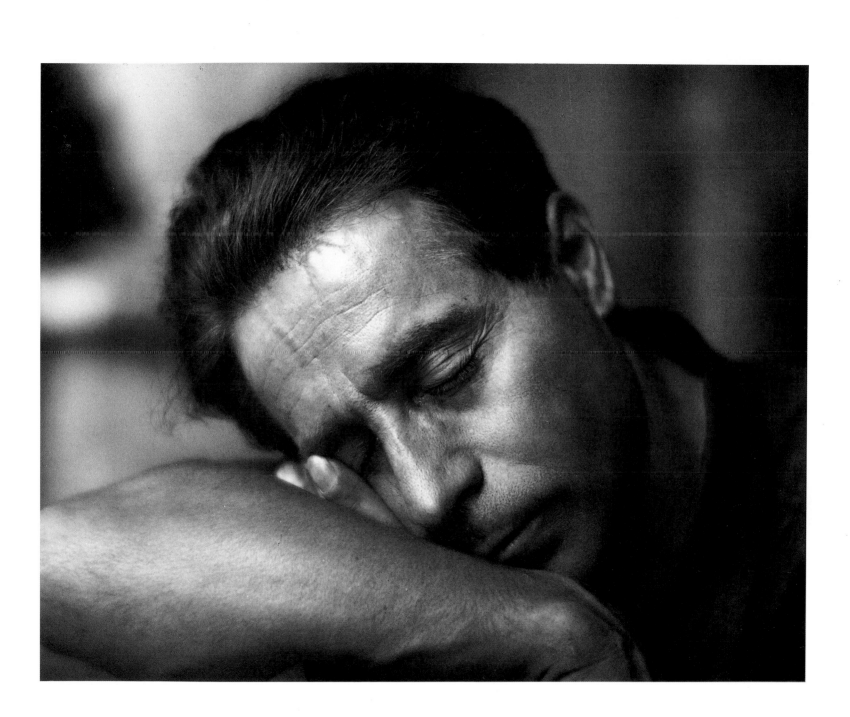

Johan Hagemeyer
Beniamino Bufano, 1938

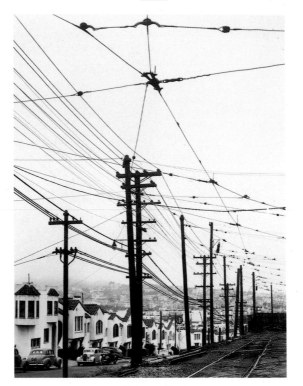

Minor White
Caryards, August 1946

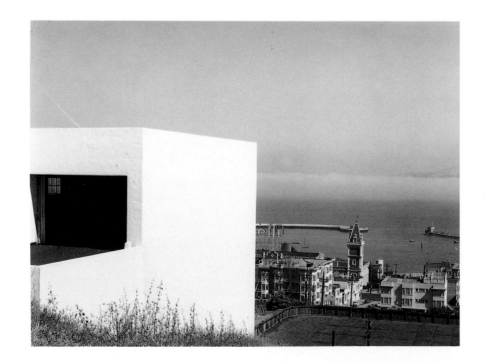

Minor White
Chestnut Street—Aquatic Park, July 8, 1949

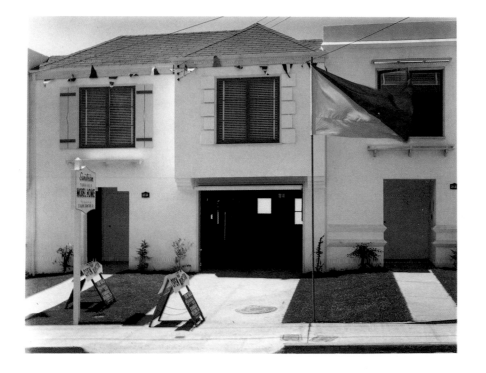

Minor White
2131 12th Avenue, August 20, 1949

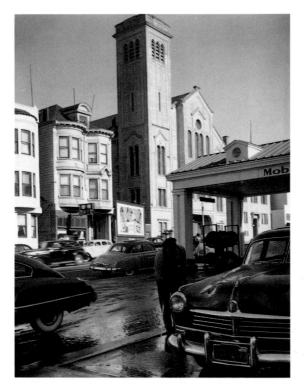

Minor White
Japanese Church, December 1, 1949

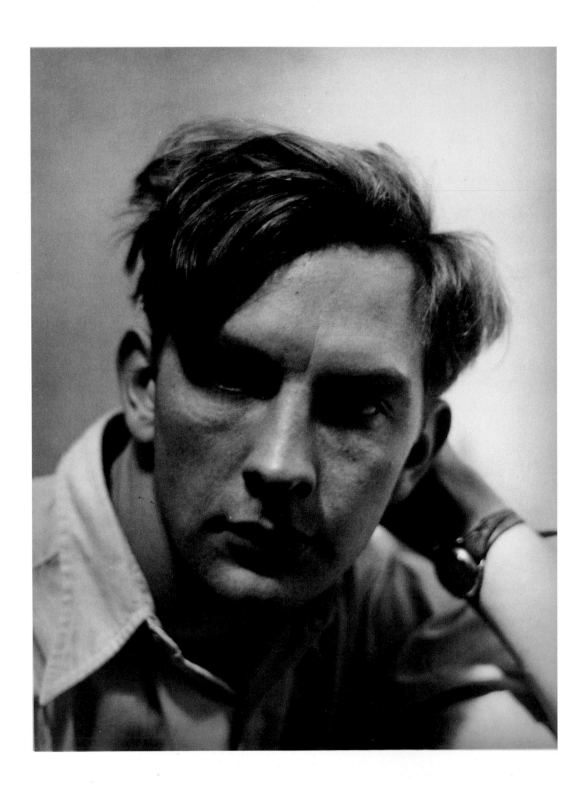

Dorothea Lange
Roger Sturtevant, c. 1931

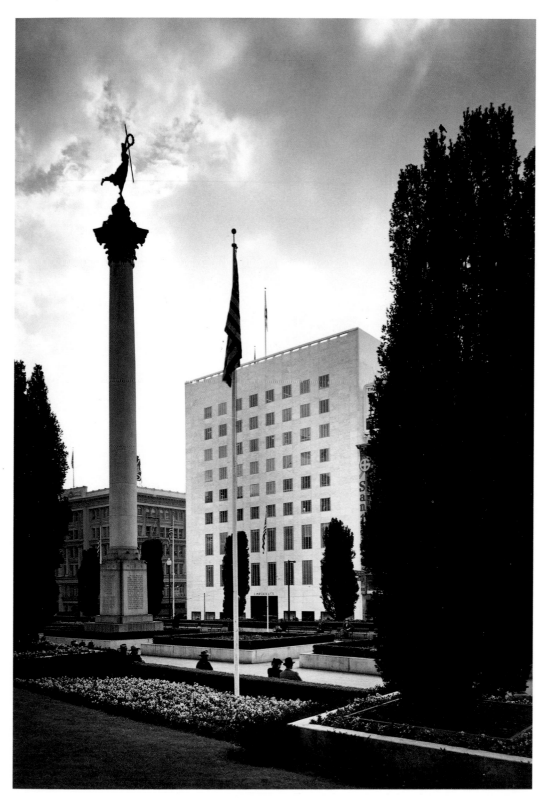

Roger Sturtevant
I. Magnin, 1948

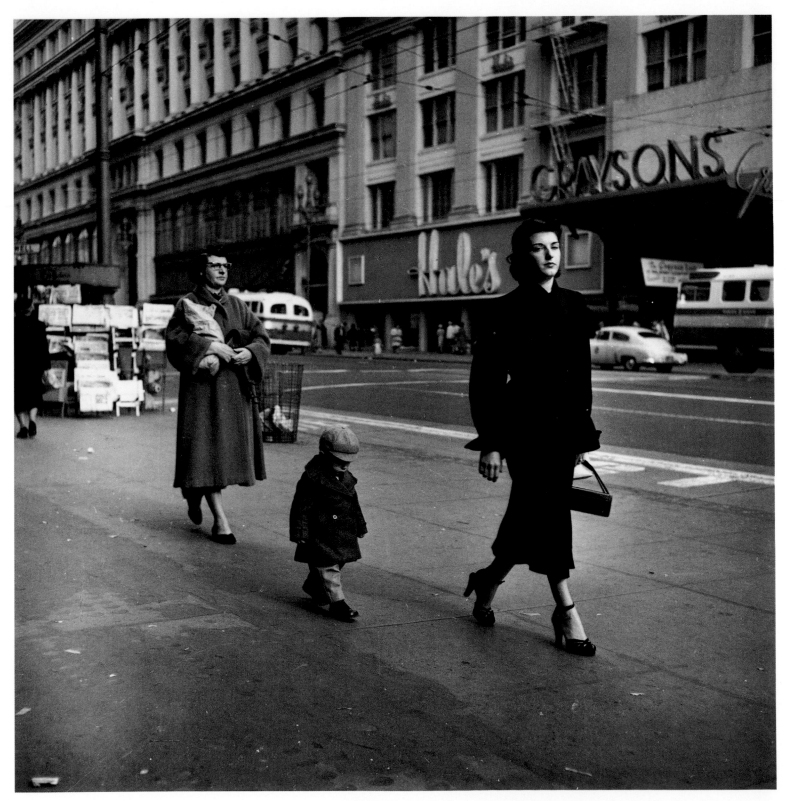

Dorothea Lange
Mother and Child, 1952

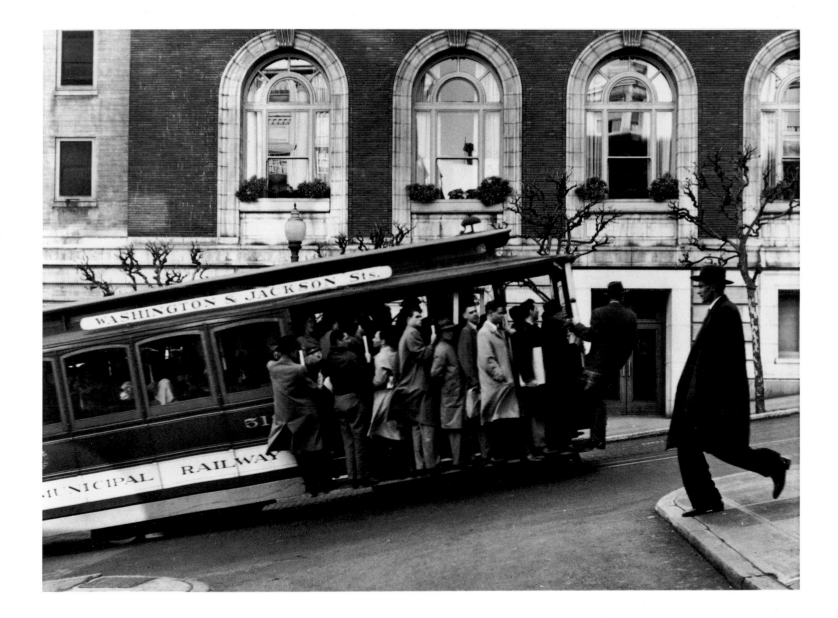

Max Yavno
Cable Car, 1947

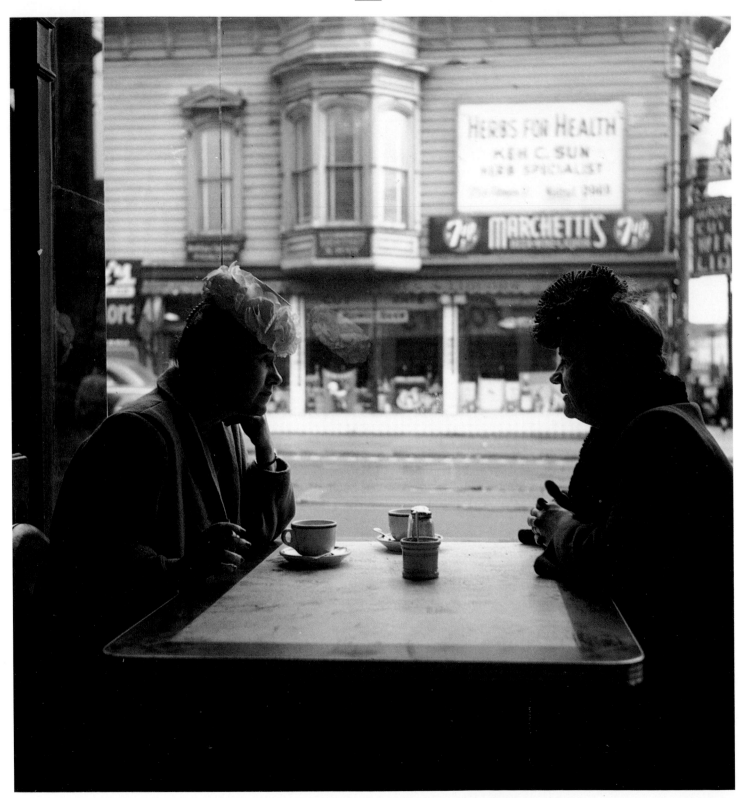

Imogen Cunningham
Tea at Foster's, before 1950

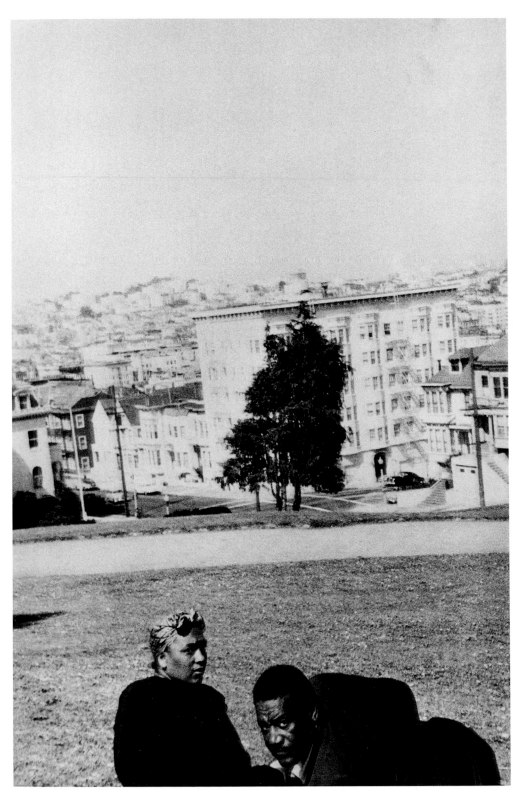

Robert Frank
San Francisco, 1955–56

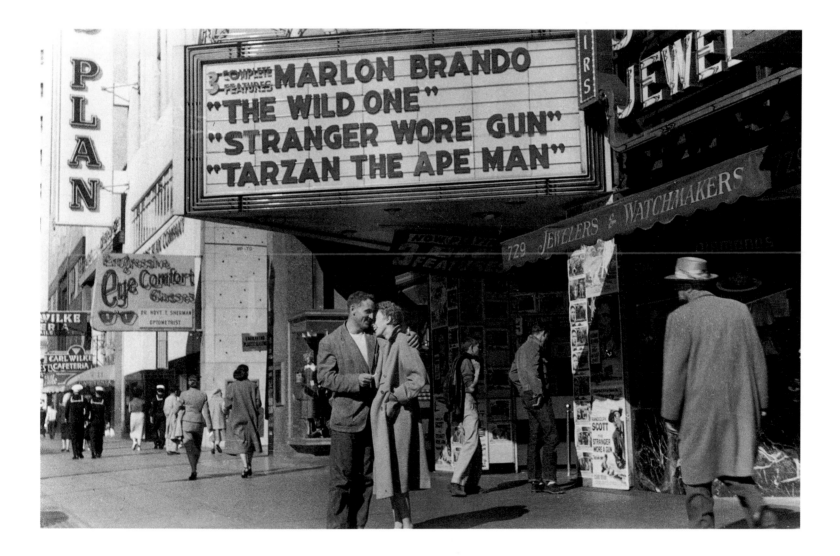

Allen Ginsberg
Neal Cassady and Natalie Jackson, Market Street, 1955

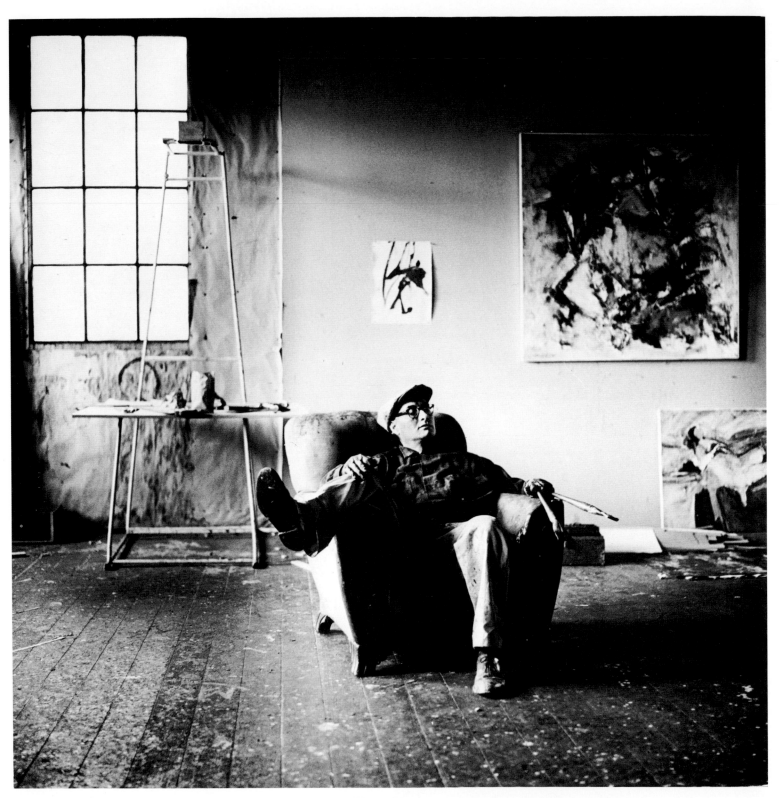

Elaine Mayes
John Saccaro, 1962

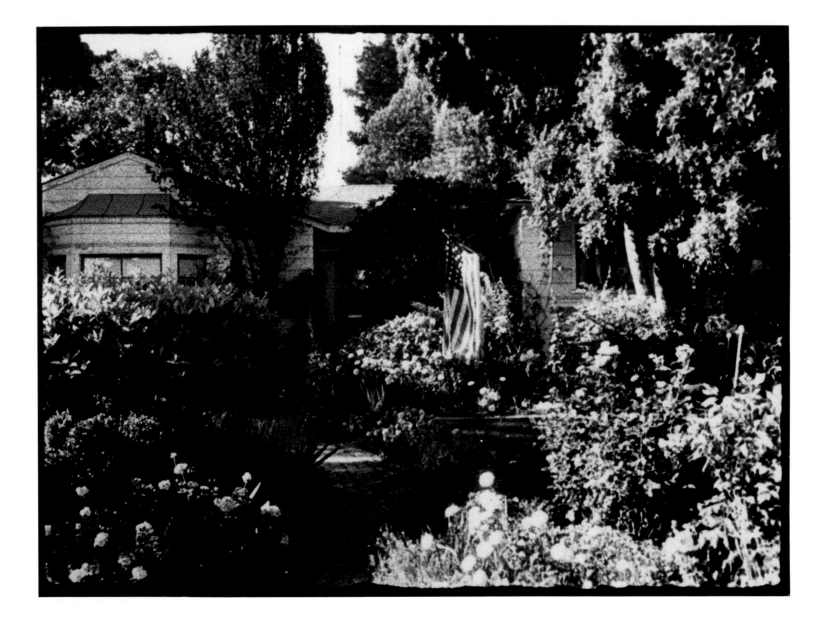

Bill Arnold
Fourth of July House, 1970

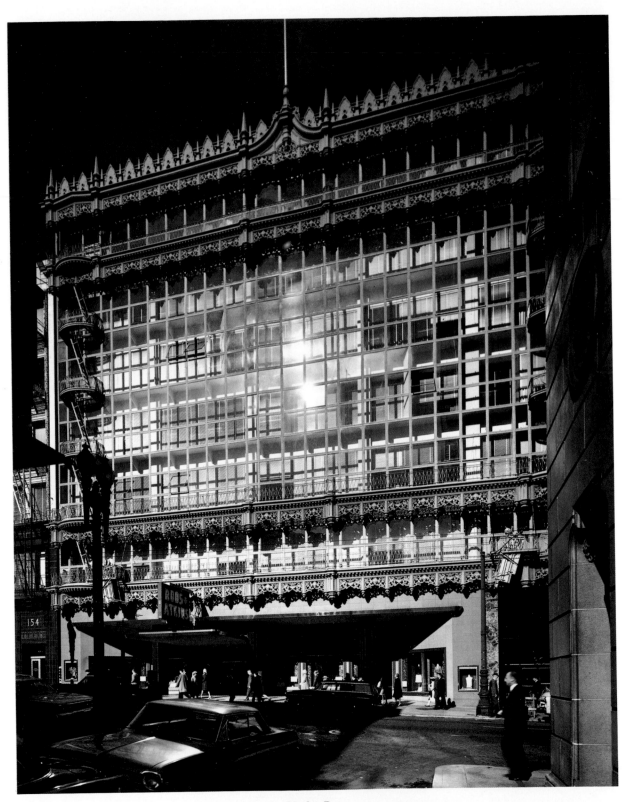

Morley Baer
Hallidie Building, 1965

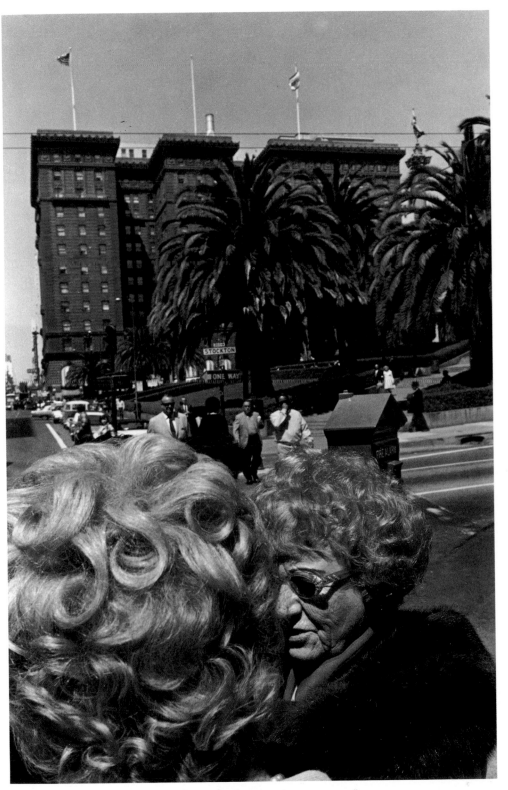

Lee Friedlander
San Francisco, 1970

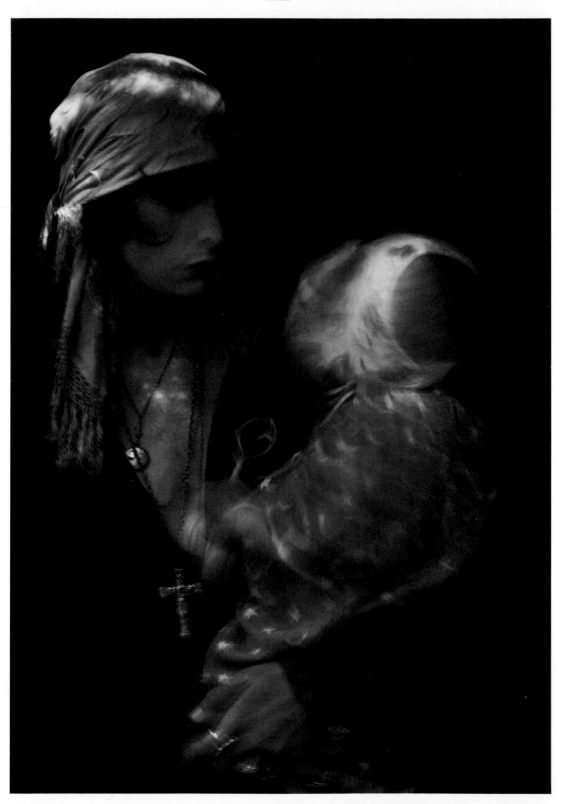

Judy Dater
Kathleen and China, 1972

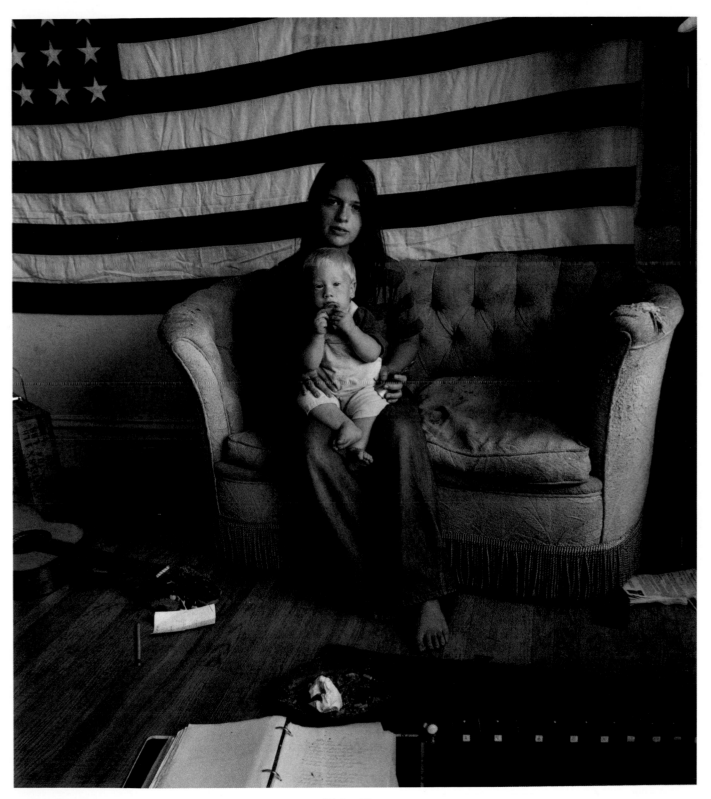

Elaine Mayes
Kathleen and Max Demian Goldman, Ages Twenty-two and One Year, Cole Street, 1968

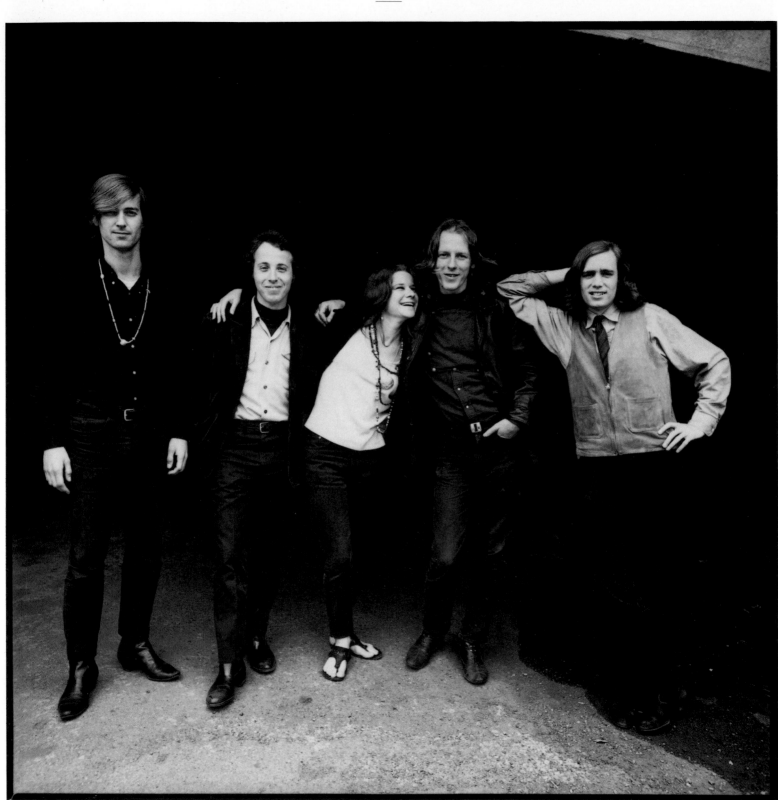

Herbie Greene
Big Brother & the Holding Company in Golden Gate Park, 1967
(from left, Sam Andrews, David Getz, Janis Joplin, James Gurley, and Peter Albin)

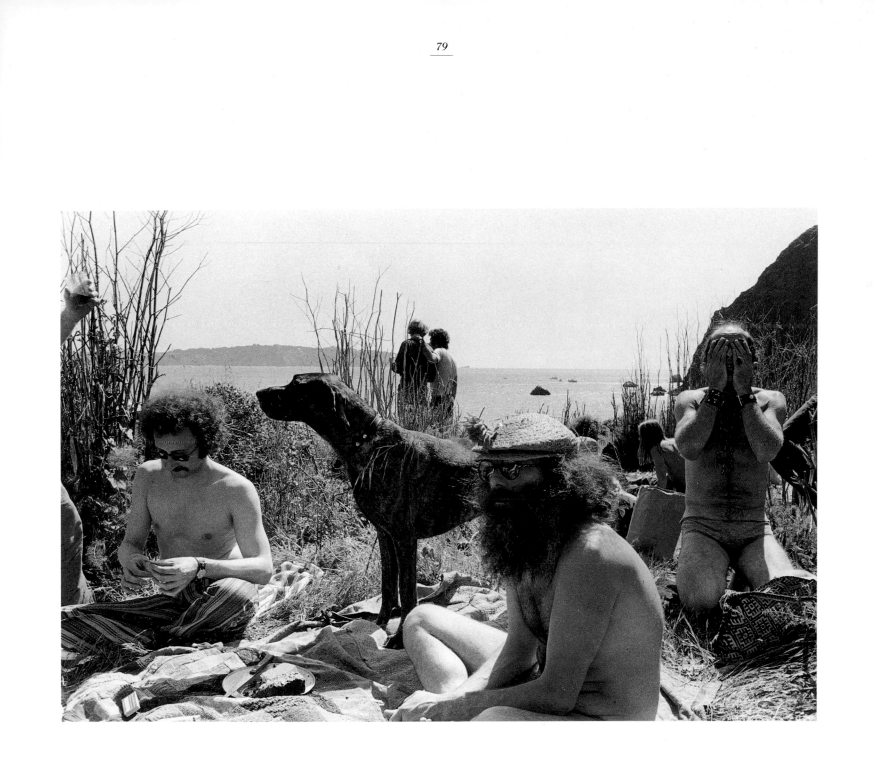

Elaine Mayes
Gays' and Artists' Picnic, 1968

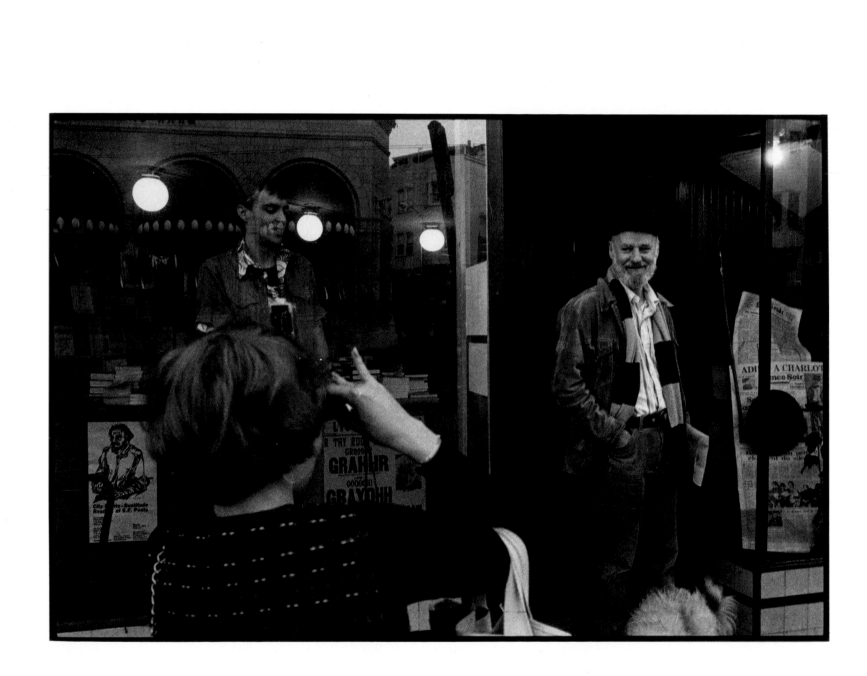

Ira Nowinski
Lawrence Ferlinghetti, City Lights Bookstore, 1977

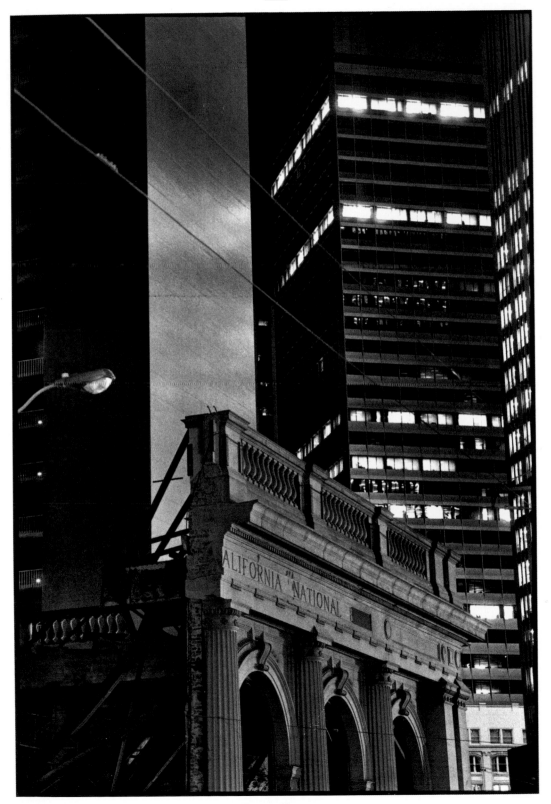

Dennis Hearne
Sutter at Market, 1982

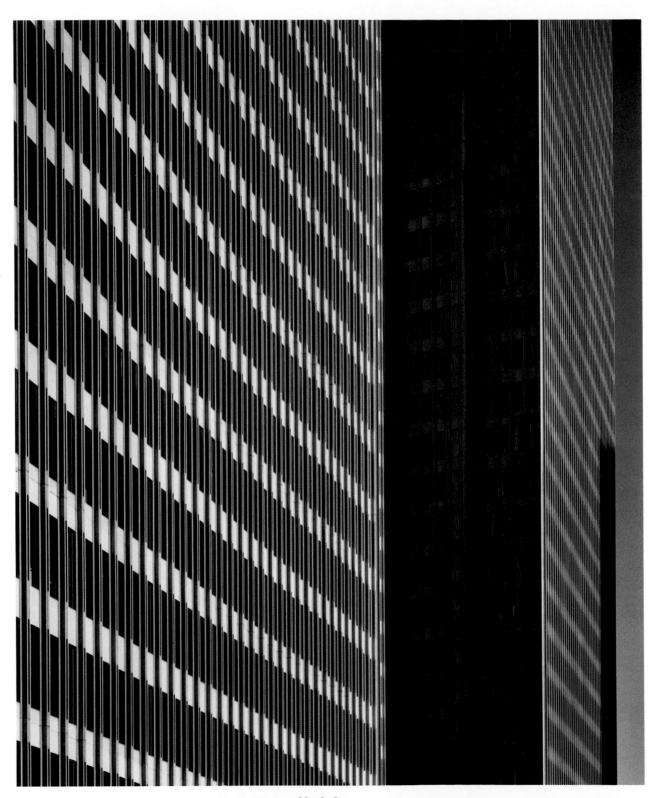

Mark Citret
Embarcadero Centers, Three and Four, 1984

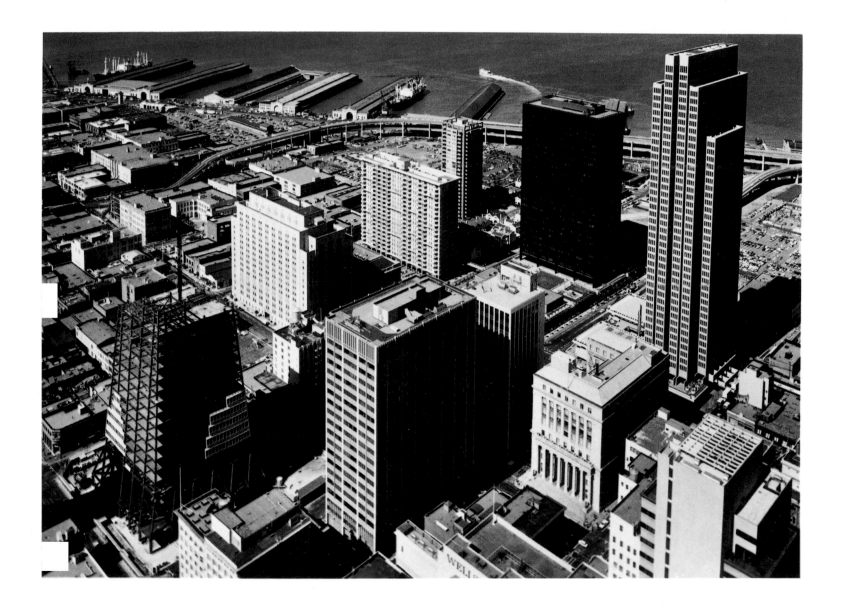

Lewis Baltz
Transamerica Pyramid, c. 1972

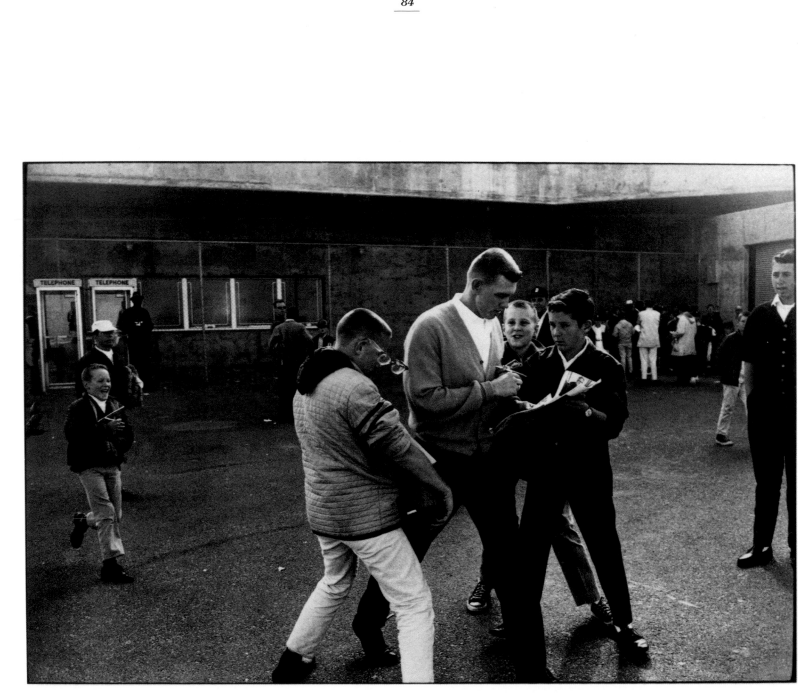

Garry Winogrand
Candlestick Park, 1964

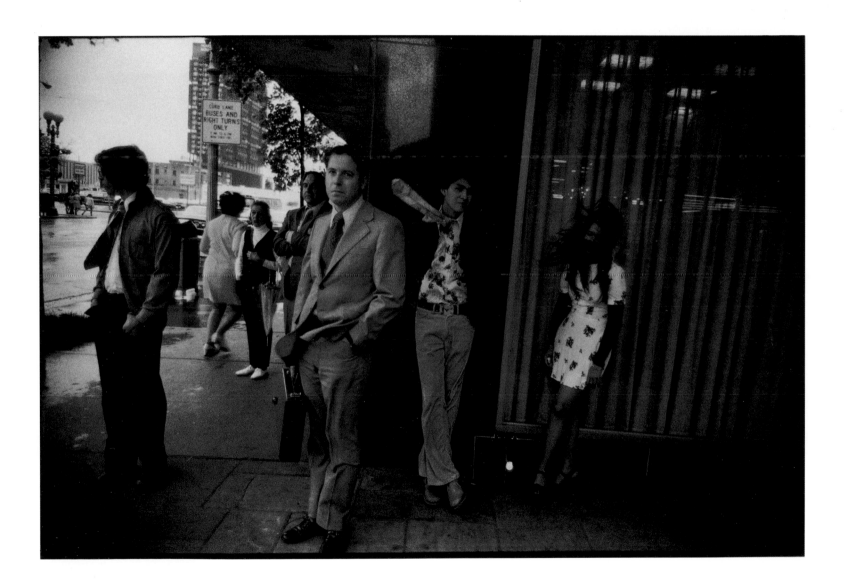

Garry Winogrand
San Francisco, late 1970s

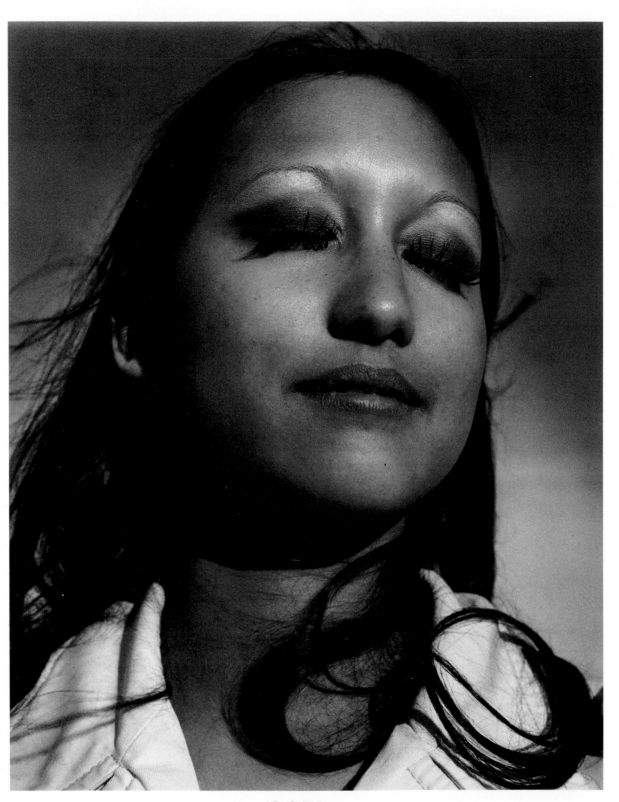

Jack Welpott
Theresa, 1973

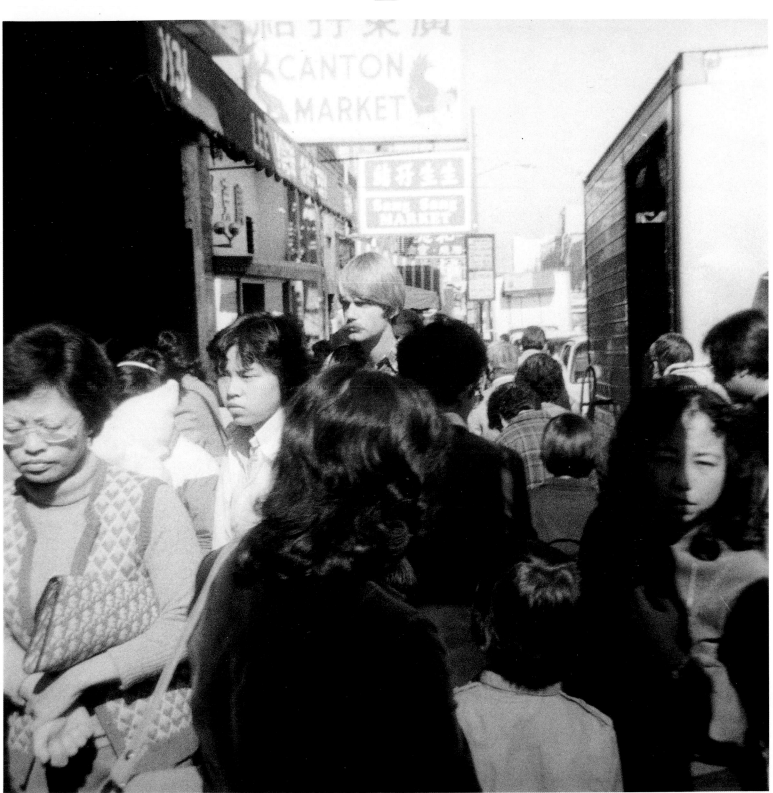

Bernard Plossu
Chinatown, 1972

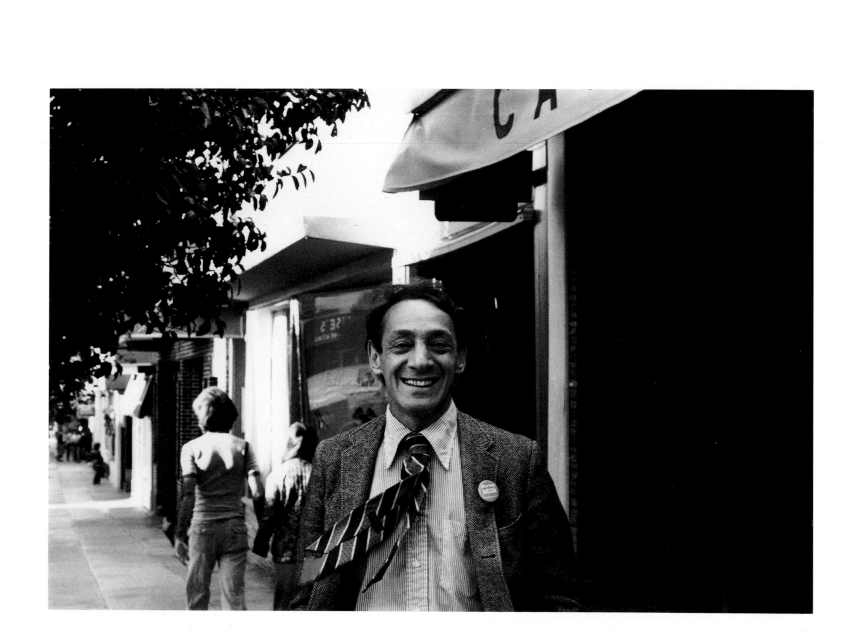

Daniel Nicoletta
Harvey Milk in Front of his Castro Street Camera Store, c. 1976

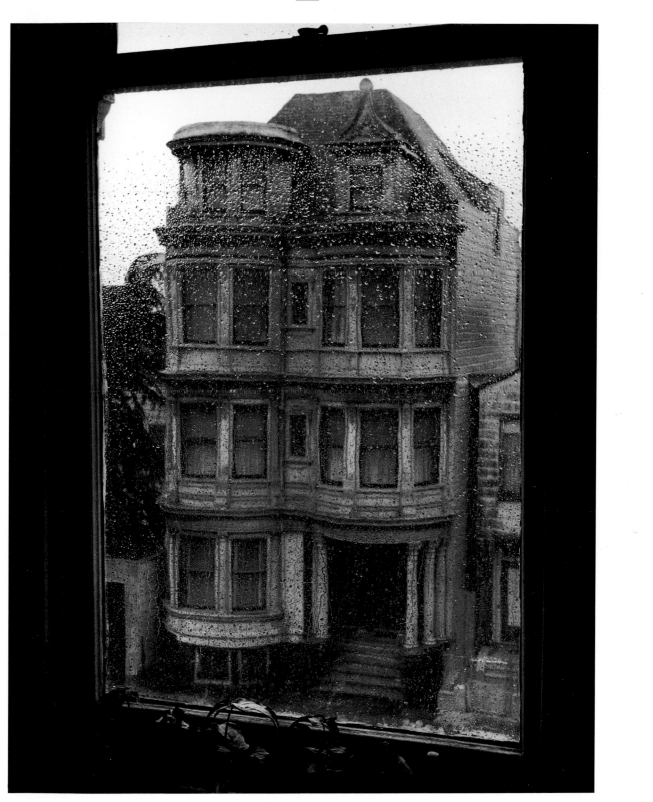

Ruth Bernhard
Victorian House, 1963

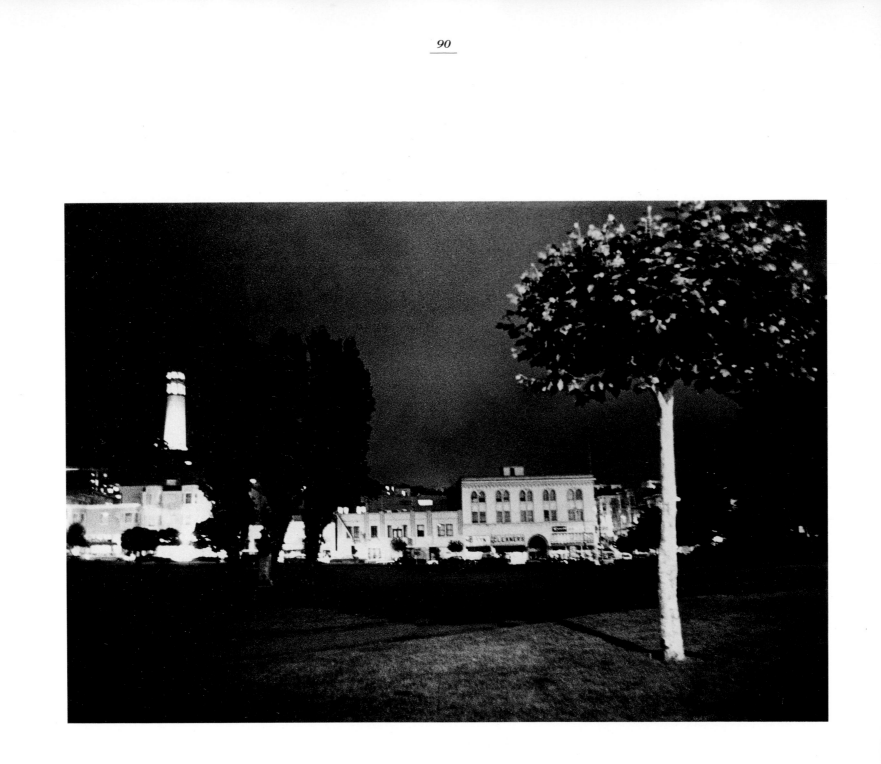

Jerry Burchard
Washington Square Park, 1969

Charly Franklin
Herb Caen, 1981

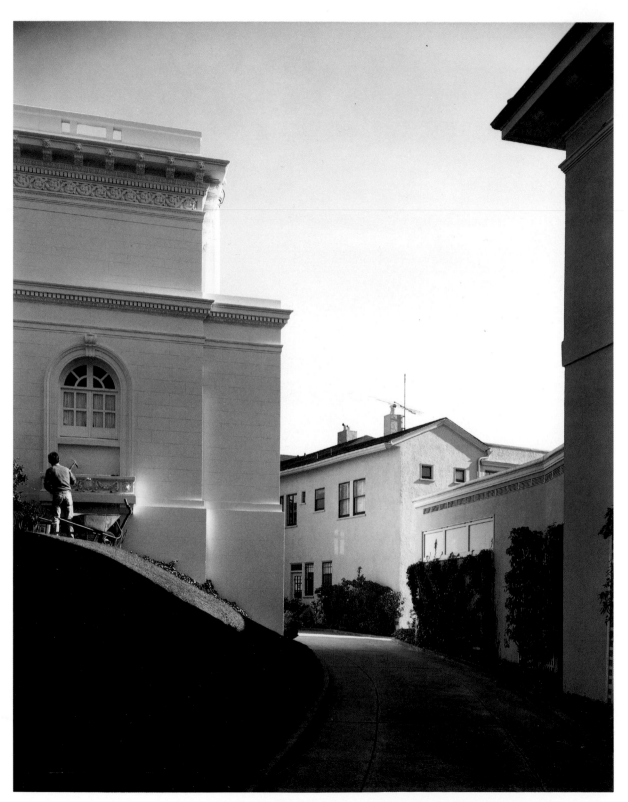

Frank Gohlke
Driveway Near the Presidio, 1979

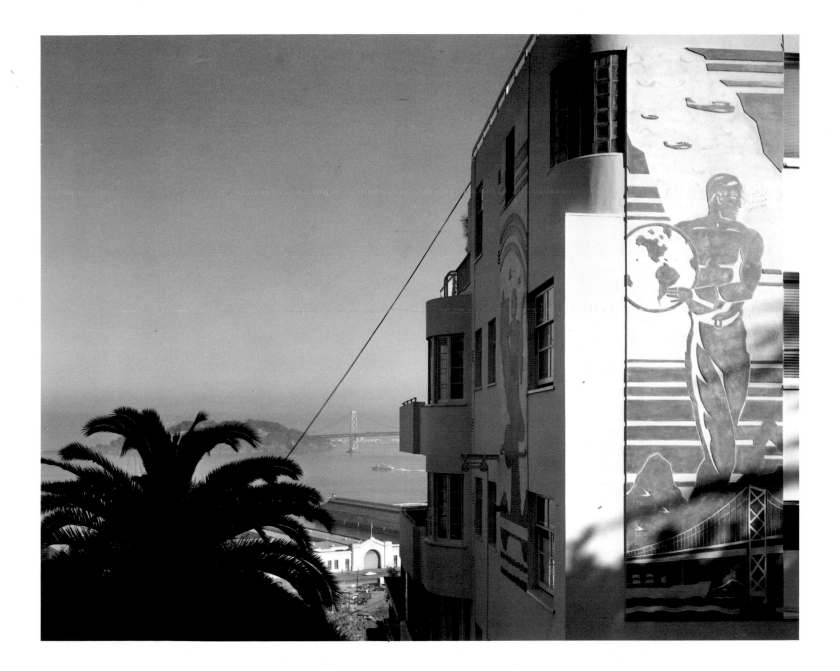

Frank Gohlke
View of Bay Bridge, 1979

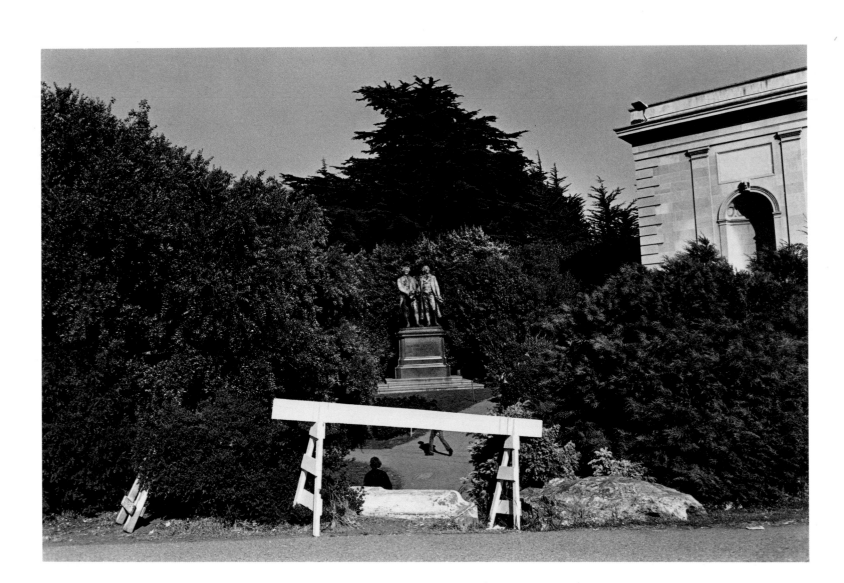

Lee Friedlander
Golden Gate Park, 1972

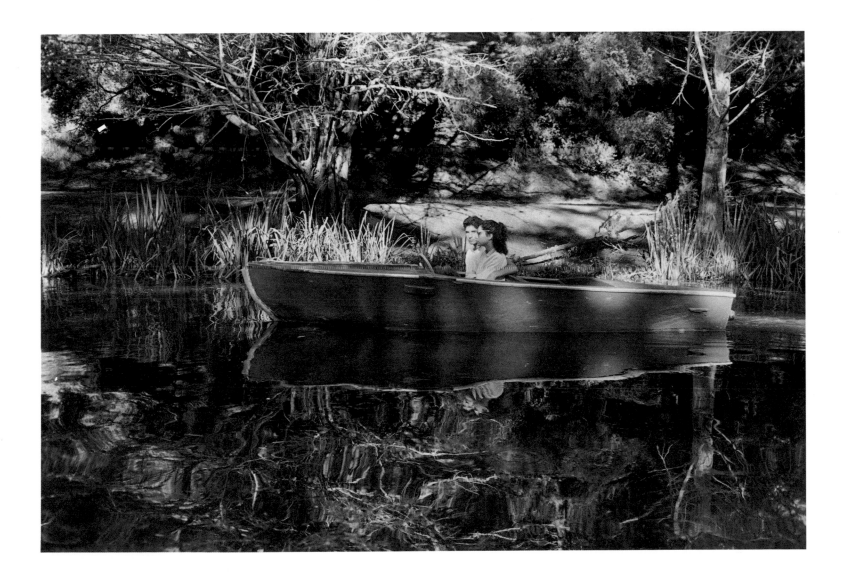

Henry Wessel
Golden Gate Park, 1983

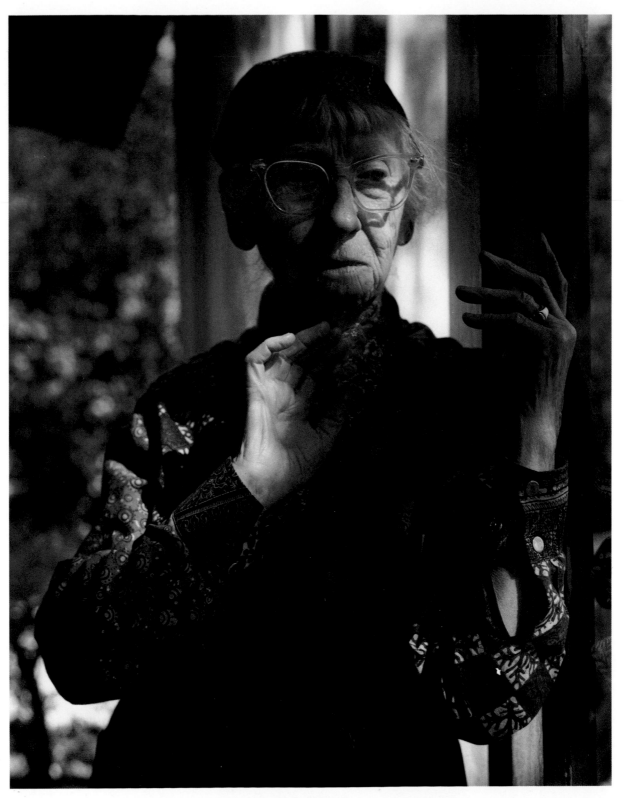

Jack Welpott
Imogen Cunningham, 1975

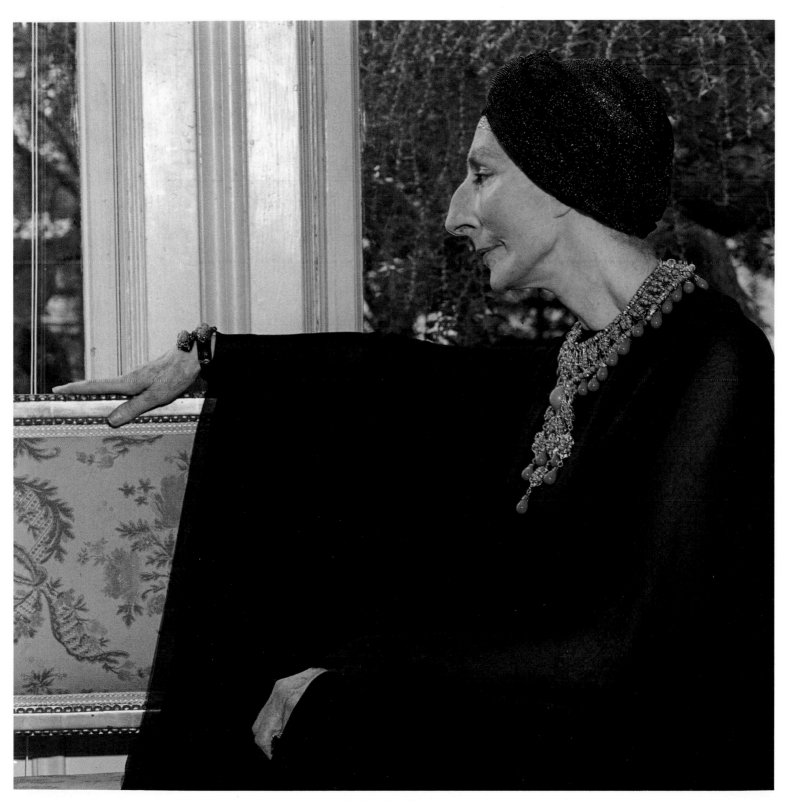

Robert Mapplethorpe
Katherine Cebrian, 1980

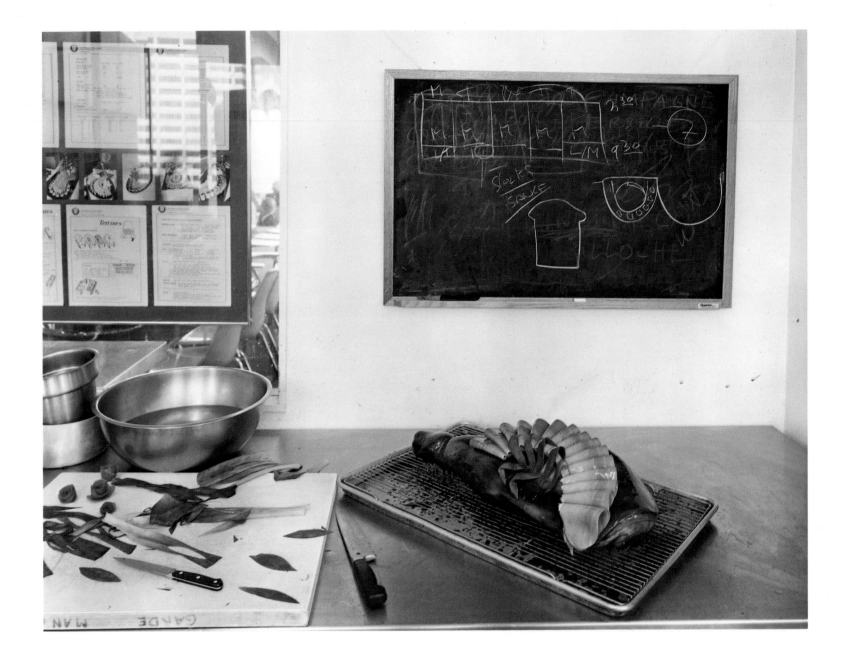

Catherine Wagner
California Culinary Academy, 1986 (from American Classrooms Series)

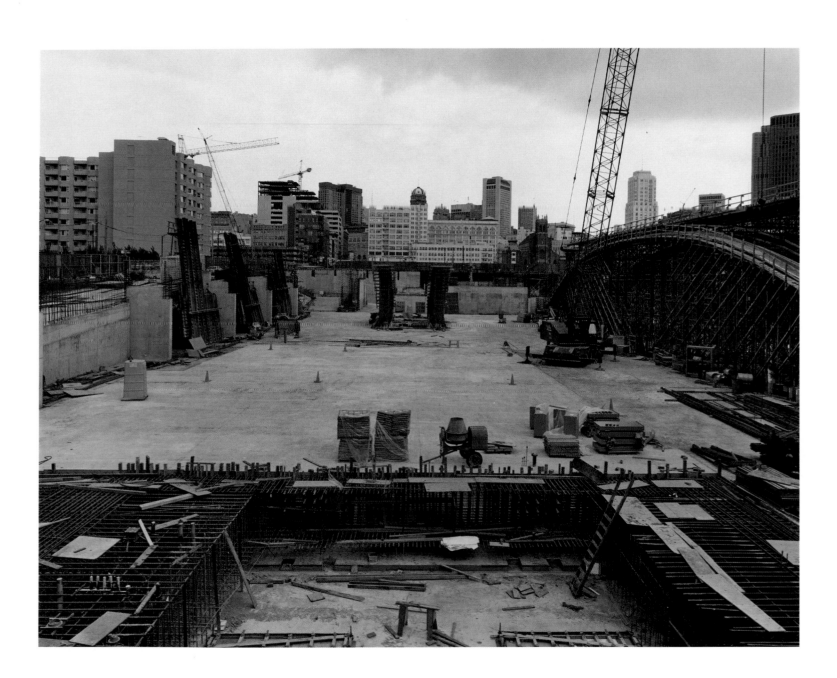

Catherine Wagner
Moscone Center, Northwestern Corner with Sawhorse and Cement Mixer, 1981

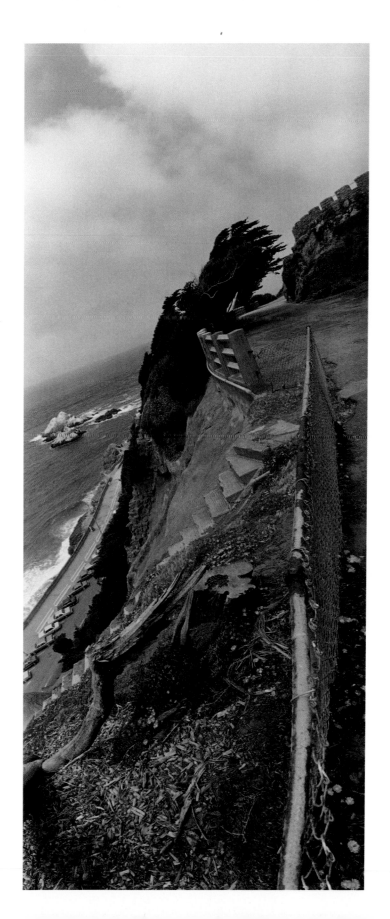

Laura Volkerding
Seal Rocks, 1981

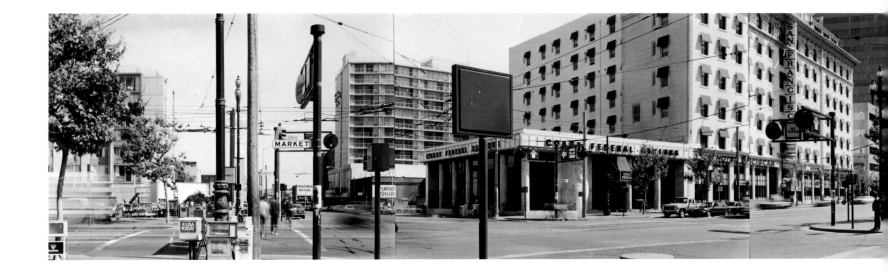

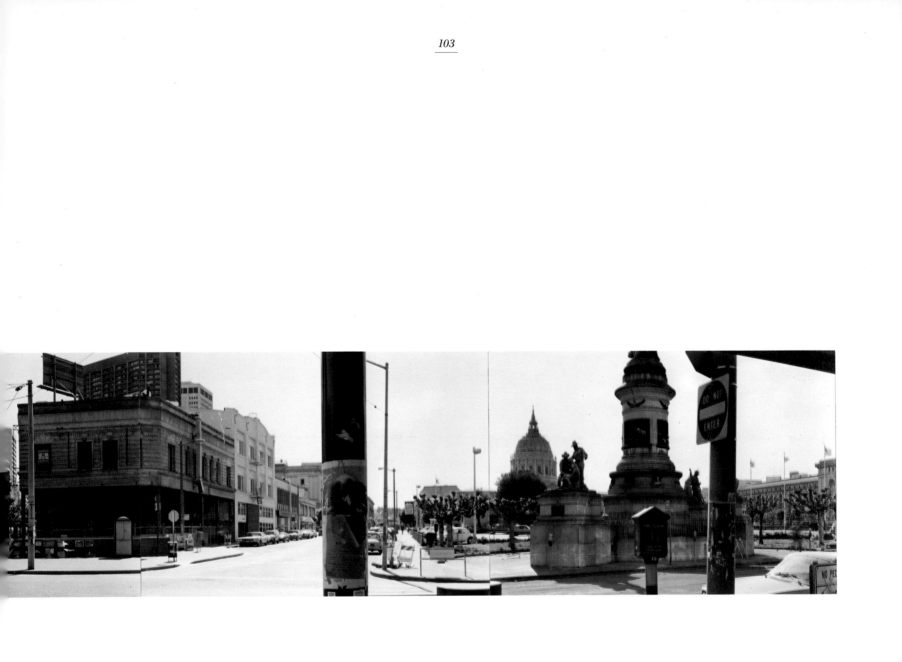

Laura Volkerding
Panoramic view from the intersection of Hyde, Grove, Market and 8th Streets, 1985

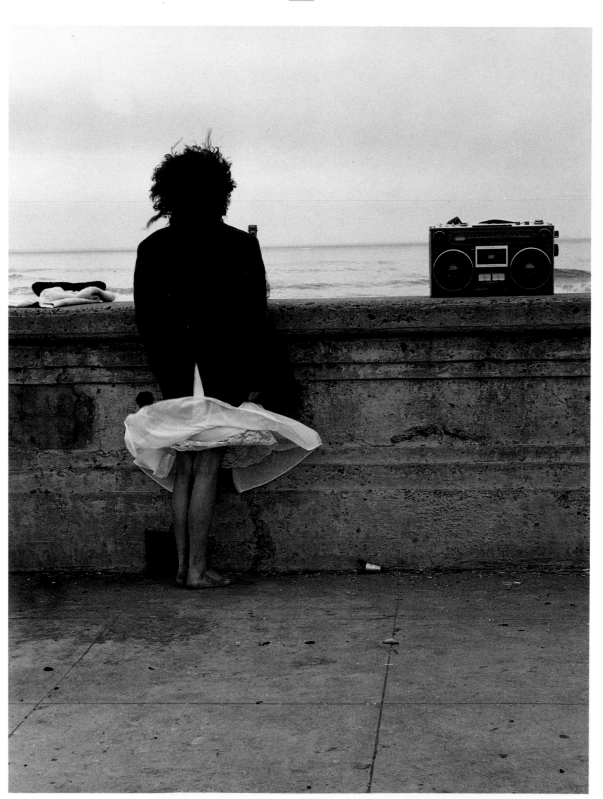

Leon Borensztein
Girl on the Beach, 1982

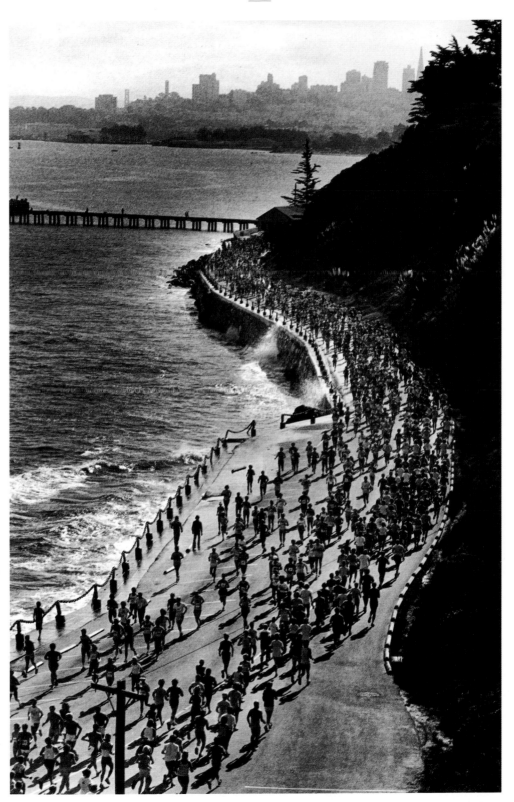

Steve Ringman
Bridge to Bridge Run, 1982

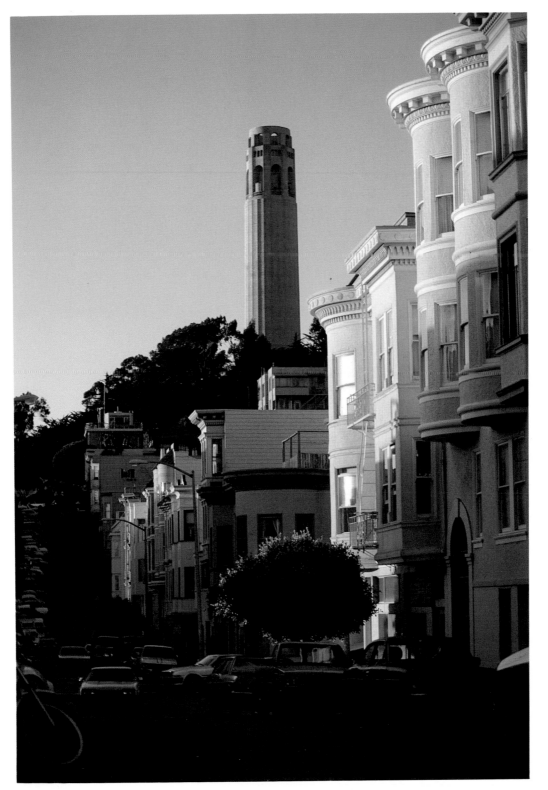

Morton Beebe
Coit Tower, n.d.

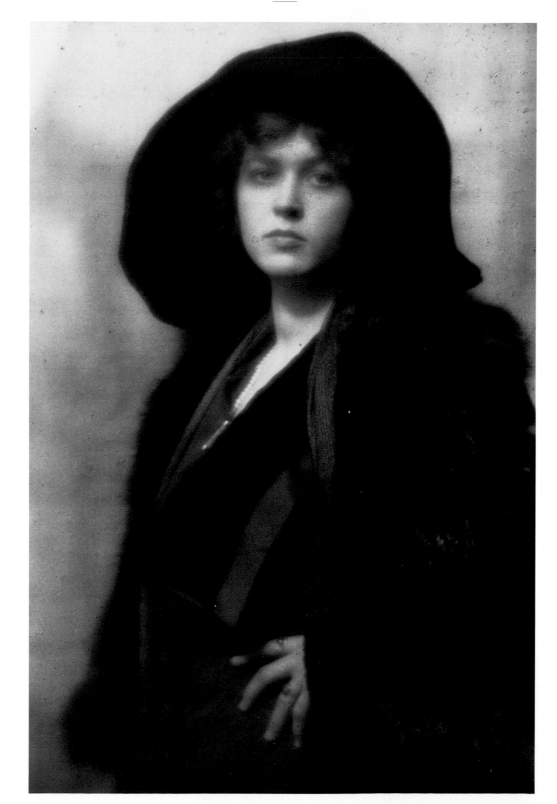

Arnold Genthe
San Francisco Beauty, c. 1910
Autochrome

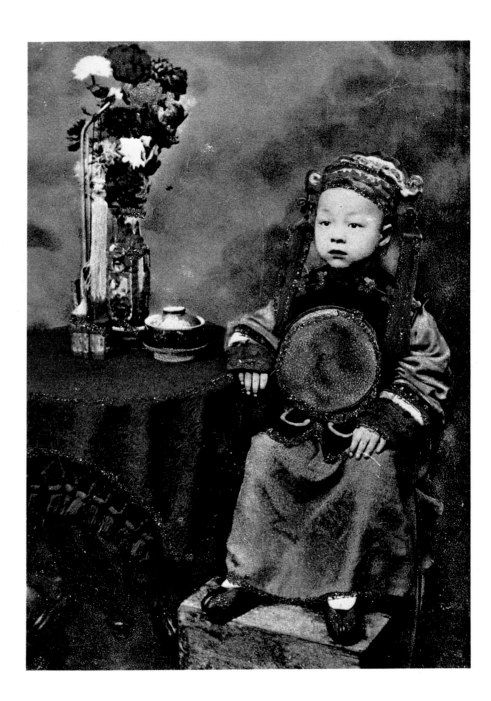

Britton and Rey Lithographers
Chinese Boy in Holiday Attire, before 1910

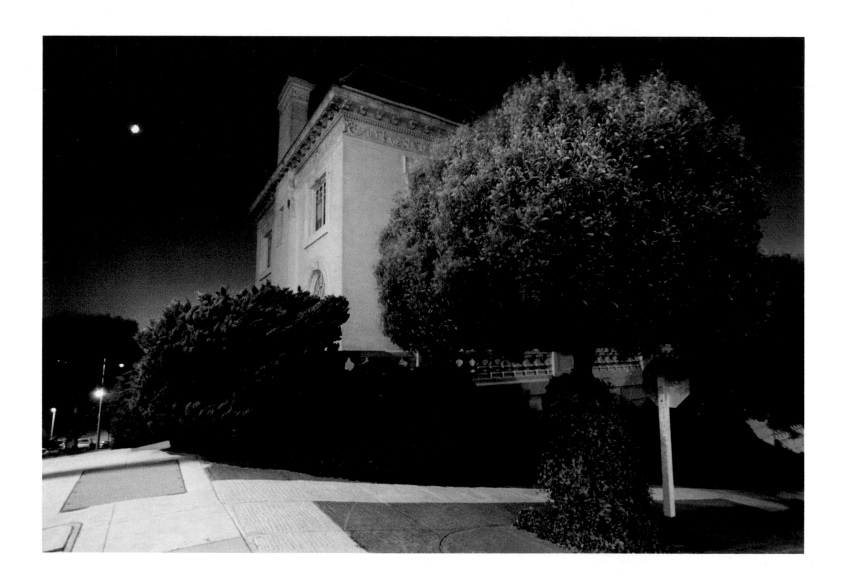

Arthur Ollman
Mansion—Divisadero Street, 1977

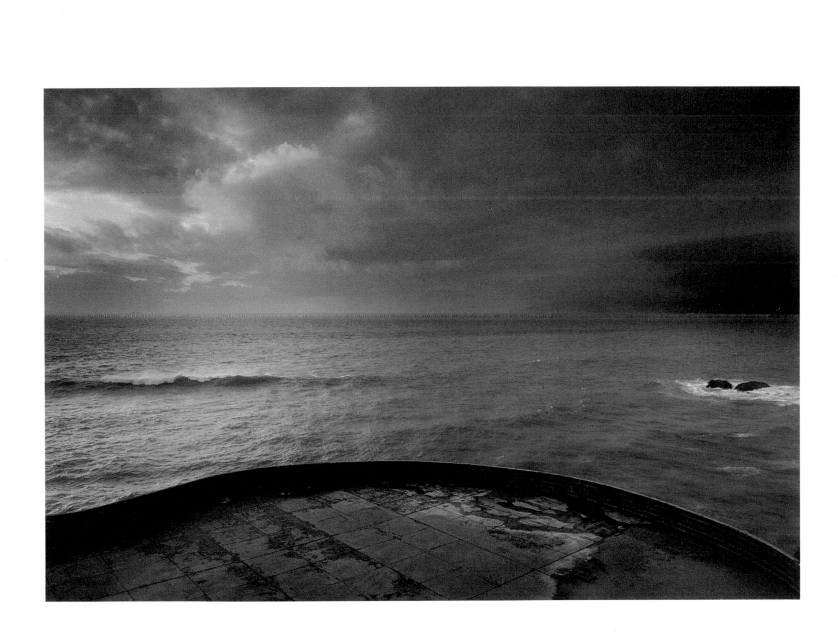

Len Jenshel
untitled, 1978

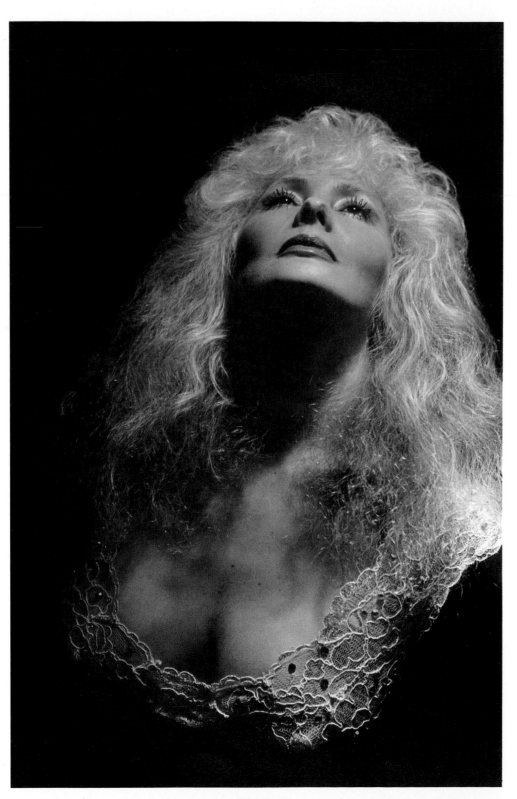

Ann Rhoney
Carol Doda, 1986

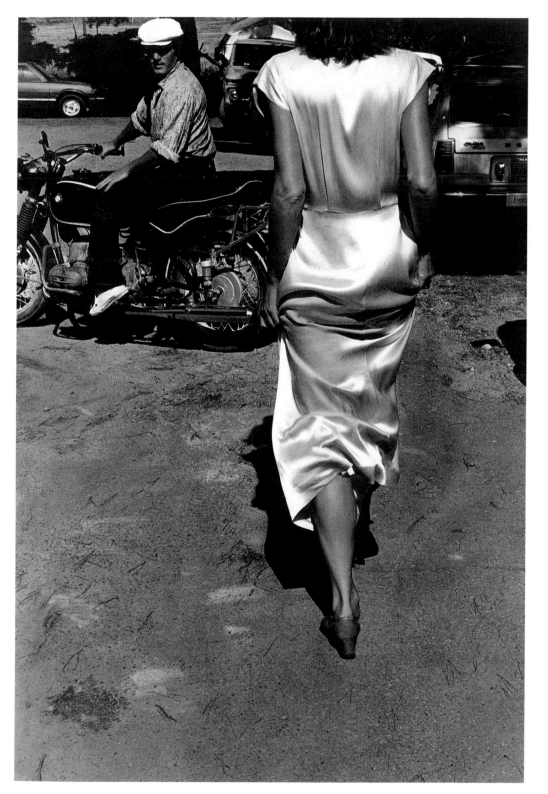

Ann Rhoney
Sally Robertson, 1982

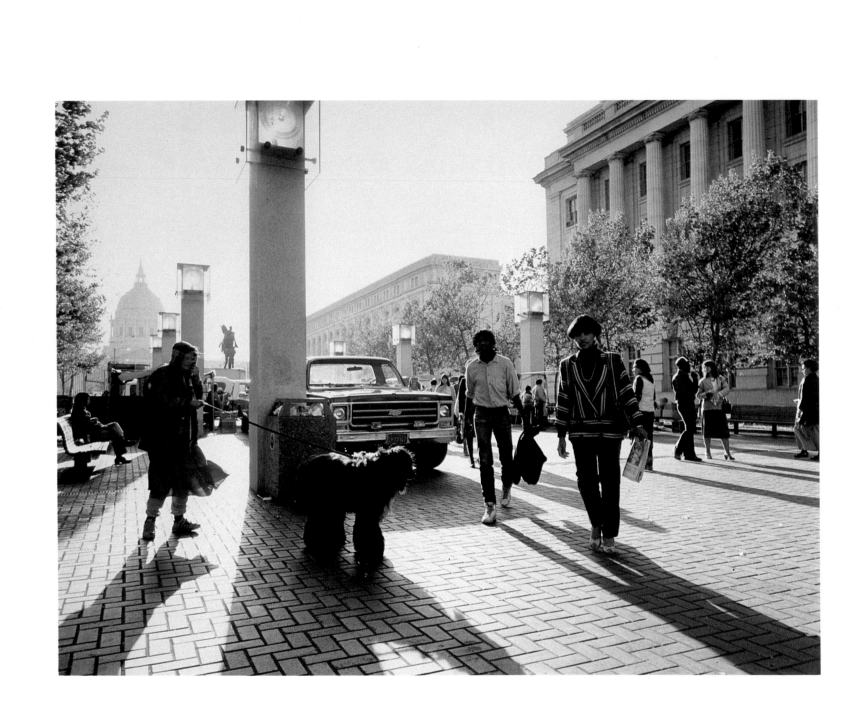

John Harding
untitled, 1985

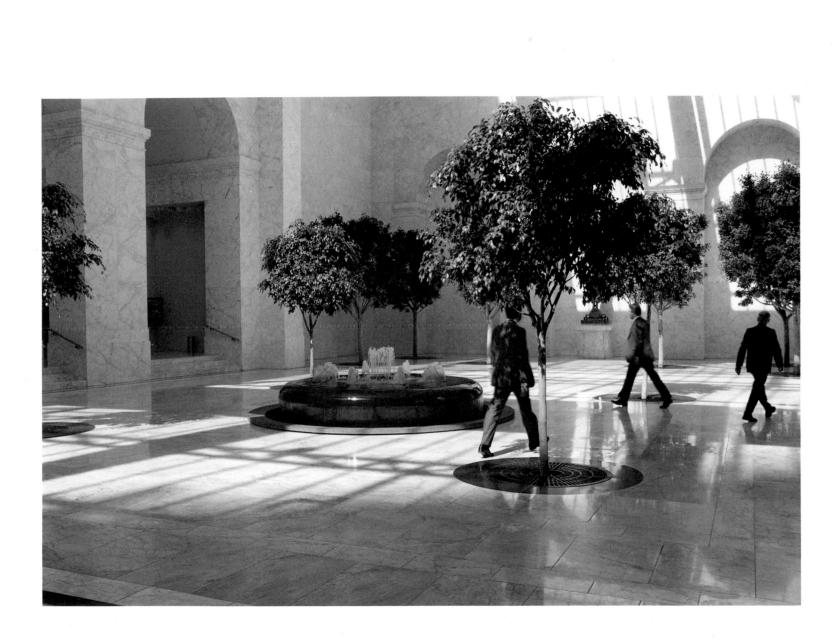

Douglas Muir
Citicorp Atrium, 1985

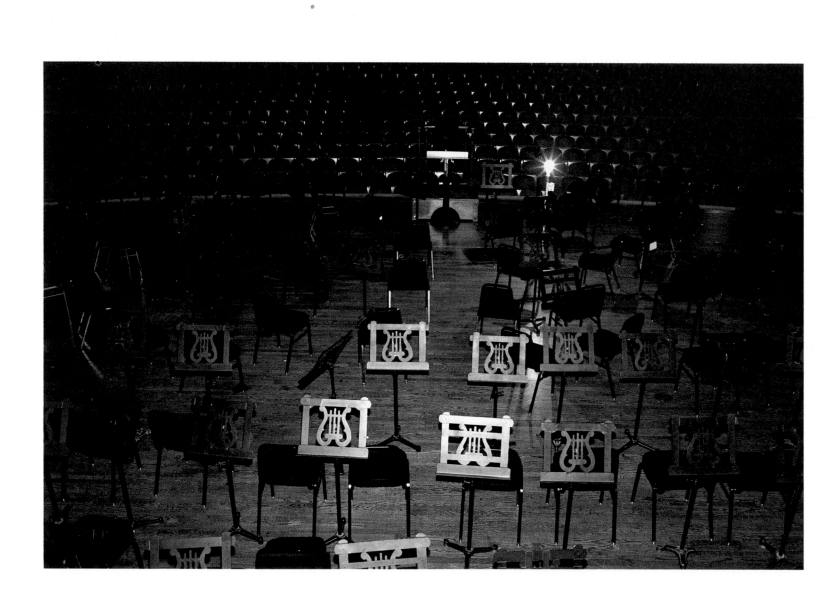

Bill Dane
Davies Symphony Hall, 1982

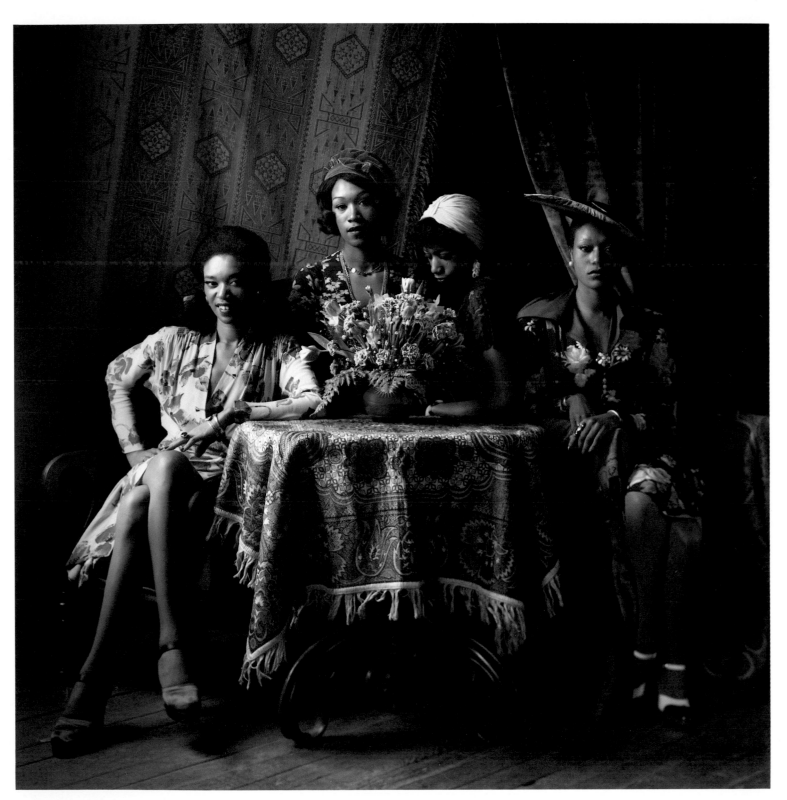

Herbie Greene
The Pointer Sisters, 1983

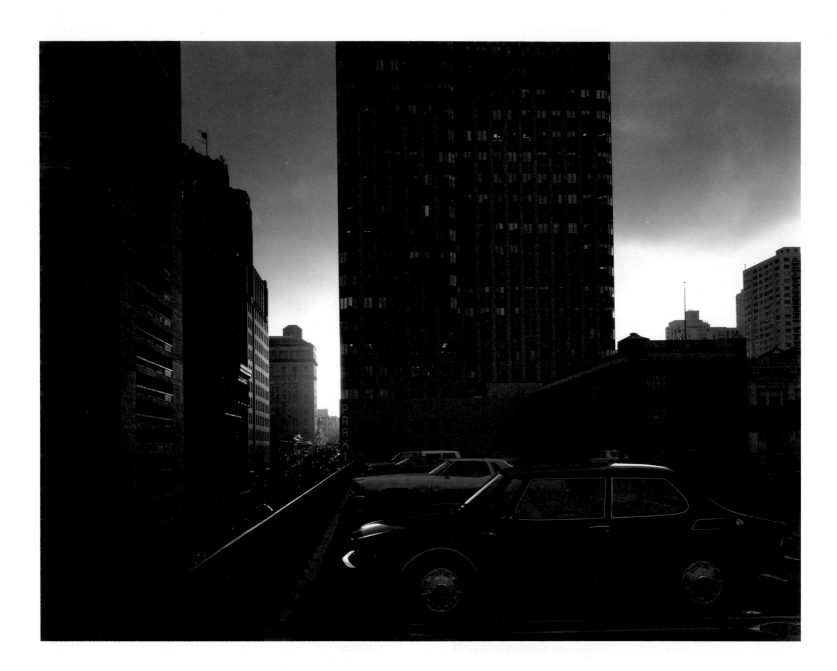

Janet Delaney
View from Sutter Street Garage, 1984

Credits

Acknowledgements

Credit for the idea of this book belongs to Fearn Cutler of Chronicle Books who hoped that a survey of fine photography such as I had made for our favorite creatures in *The Dog Observed* (Knopf, 1984) might be made for San Francisco, our favorite city. She and everyone at Chronicle Books have been wonderful to work with throughout this project.

Making a collection of one hundred photographs really means making a collection of many hundreds from which to select. Finding and keeping track of all this material is an extensive task that could not be accomplished without the assistance of a multitude of others. For their parts in this effort, I would like to offer special thanks to my assistant, Rachel Wild, who did everything perfectly and made everything fun; to the photographer, Ann Rhoney, whose friendship and help with research were invaluable; to the photographer, Doug Muir, whose interest and recommendations made a great contribution; and to my mother, in Oakland, California, for her patient and ongoing support.

In addition to those whose credits are mentioned with the photographs, I want to acknowledge and thank the following people for their essential participation: Marilyn Blaisdell; John Bloom, Henry Brimmer and Therese Randall of *Photo Metro;* Elise Breall, The Fine Arts Museums of San Francisco; Beverly Brannan and Mary Eisen, The Library of Congress; Tom Cole; Tim Eaton; Larry Fong and staff, Center for Creative Photography; Julie Freshman and Bonni Benrubi, Daniel Wolf, Inc.; Jeff Fraenkel and Frish Brandt, Fraenkel Gallery; Susan Friedenwald; Peter Galassi, The Museum of Modern Art, New York; Stephen Fletcher, Curator of Photographs, and Gerald Wright, California Historical Society; Therse Heyman, Senior Curator of Prints and Photographs, and Loretta Gargan, The Oakland Museum; Ron Jehu; Mary Kelledy, Pflueger Architects; Sara Leith and Anita Gross, The San Francisco Museum of Modern Art; Juanita Lieberman, Assistant to Allen Ginsberg; Thomas Moulin and Deborah Morley, Moulin Studios; Ira Nowinski; Annagret Ogden and Richard Ogar, The Bancroft Library; Richard Pare, Curator of Photographs, Lori Gross and Libby McCoy, The Canadian Centre for Architecture; Elizabeth and Ron Partridge; my colleague and friend, Toby Quitslund; Howard Read, Robert Miller Gallery; Stu Smith, The San Francisco Giants; David Spear; Tina Summerlin; and all of the librarians and gallery and bookshop assistants who helped unwittingly and whose names I did not learn.